A GRAPHIC COSMOGONY

24 ARTISTS TAKE ON 7 PAGES TO TELL THEIR
TALES OF THE CREATION OF EVERYTHING

IN THE BEGINNING...

INTRODUCTION BY PAUL GRAVETT

When it comes to the birth of comics, like the birth of the cosmos, it's still open to speculation. The Book of Genesis might open with 'In the beginning was the word', but it seems more than likely that 'In the beginning was the picture'. Or at least a picture which served as a word, a visual vehicle for representation and meaning. Mankind surely drew before we could write, but why make a distinction anyway? After all, the Chinese use the same word to mean both writing and drawing. And we know that many letter or word forms began as codified shorthand drawings of what they represented. We can only guess what the very first drawings looked like on the rocky walls of our very first art galleries, cinemas, decorated temples or stained-glass-windowed cathedrals, namely our earliest ancestors' cosy, craggy caves. Most probably they included a life-size hand, daubed, smacked and printed straight onto the rock, and perhaps a simplified version of man himself, reduced to a symbolic, talismanic stick figure, the proto-cartoon or ur-comic.

There is something instinctual, almost primal about making and reading/viewing comics, especially highly graphic ones with few or no words. They spark a provocative clarity that taps into our inner caveman's brain, our pre-literate child-self deciphering to make sense of the strange wonders of the everyday. And for all our scientific advances, here we are now, only a mere decade into this second millennium, and still finding fascination in the show-and-tell choreographies of pictures, lettering, balloons, captions and panels.

So what better means than comics, the distillation of illuminated manuscripts, tapestries, meditational paintings and decorated scrolls and all of humanities' narrative arts, to tell that oldest story of them all, the story of creation?

The Biblical creation myth proposes that God created the world in seven days, or six plus one day off to chill out, so in that spirit the two-dozen cartoonist-shamans corralled into this compendium were given just seven pages to devise their own version of how we all got here. Some draw on tales from ancient traditions, such as Norse or Ainu legends or a universal mother's womb of all things. Some illustrate mainly in stylised profiles, harking back to Egyptian tomb walls or Grecian friezes. Others mostly ignore previous versions - 'It's been done to death. You have to make it up' - and take more oblique or satirical stabs. They try explaining the origins of everything as a magician's act, a simulation game, a failed school assignment, a yurt-dweller's break from boredom, the tears of a grief-stricken stag or the contents of a cyclops' vacuum-cleaner bag or the head of Derek. It's up to you whether you believe such 'dubious facts' as 'ghost energy', 'ether-juice' or the heresies of the 'Masters of the Universe'. Entire world faiths have been built on equally unlikely accounts. Perhaps if enough readers of this volume start believing in certain stories, they might cause a spate of new religions to spring up based upon them.

Pull up a rock and gather round the flickering fire - the universe is about to be born again..

ILLUMINATION

A PICTORIAL ACCOUNT OF THE TRIALS OF A DELUSIONAL SEMINARIAN

as told by
STUART KOLAKOVIC

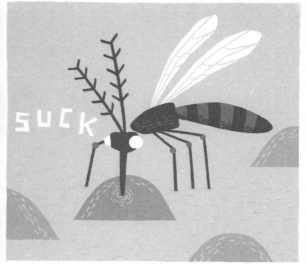

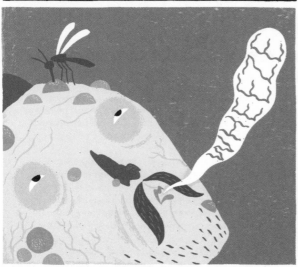

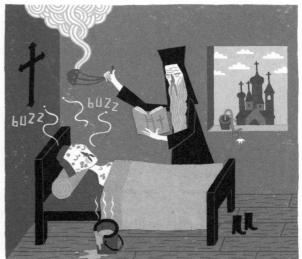

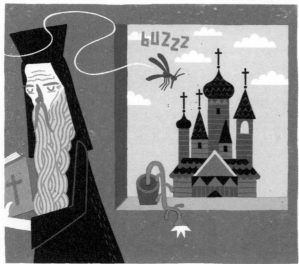

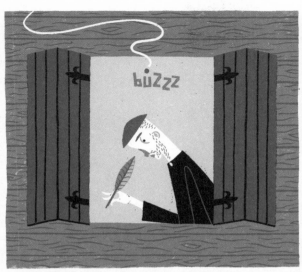

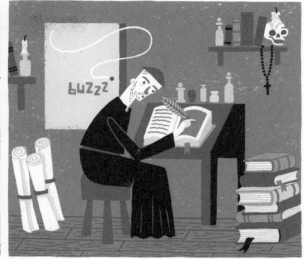

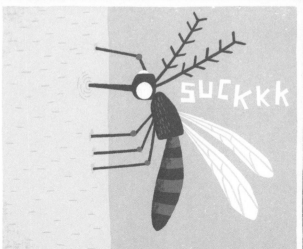

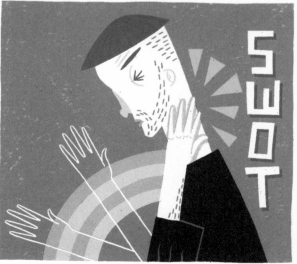

And so...

WITHIN MOMENTS, THE INFECTIOUS DISEASE TAKES POSSESSION OF ITS LATEST VICTIM...

———

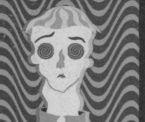

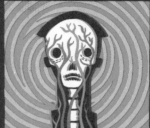

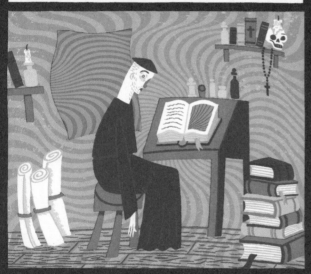

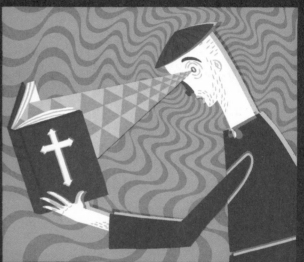

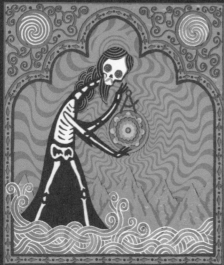

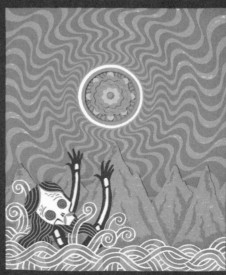

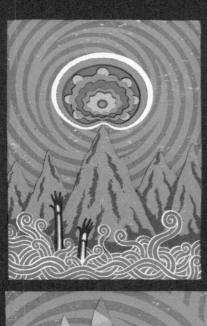

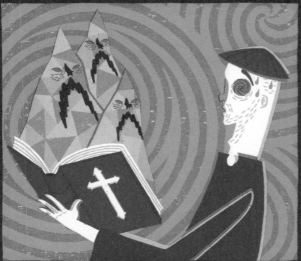
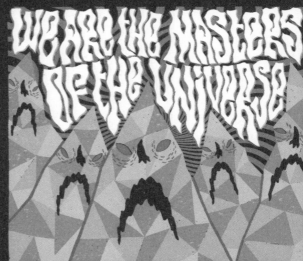
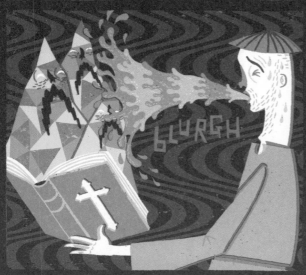
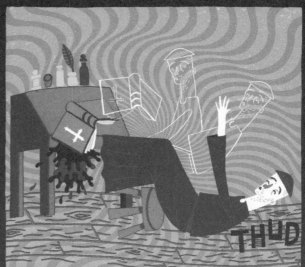

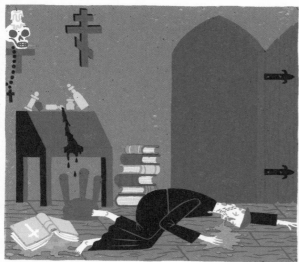
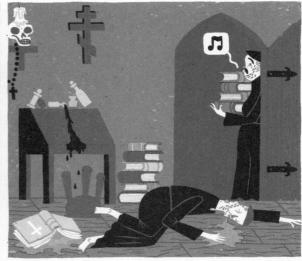
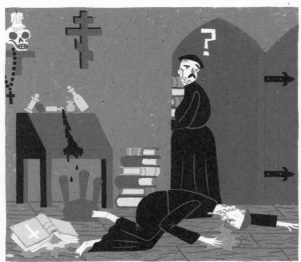

ONLY THROUGH THE SHEER CONVICTION OF HIS RECENT EPIPHANY IS THE YOUNG MONK ABLE TO FIGHT THE PESTILENCE WHICH PLAGUES HIM...

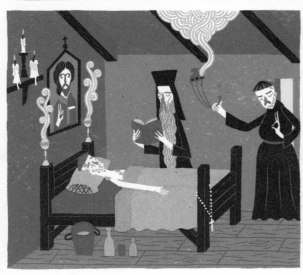
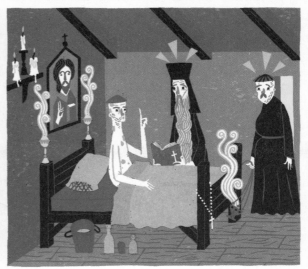

8

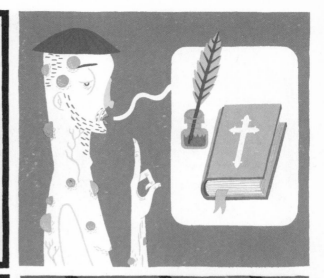

"EПОЦЭН!"

THE WHOLE WORLD MUST KNOW OF HIS DIVINE REVELATION...

———

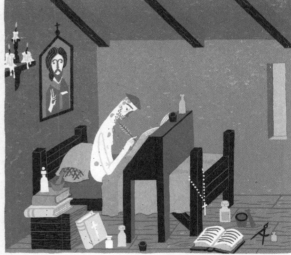

WITH REGAINING STRENGTH HE MANAGES TO COMMIT HIS COSMIC PROCLAMATION TO PARCHMENT.

———

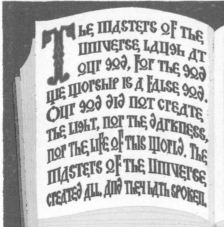

The masters of the universe laugh at our god, for the god we worship is a false god. Our god did not create the light, nor the darkness, nor the life of this world. The masters of the universe created all, and they hath spoken.

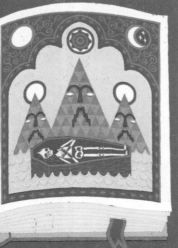

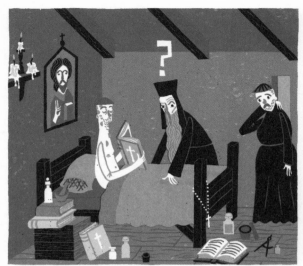

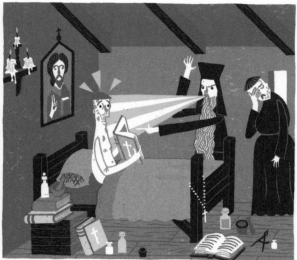

"HERETIC!
YOU SHALL BE BURNT AT THE STAKE BY THE STROKE OF MIDNIGHT FOR YOUR BLASPHEMOUS PROFANITIES!"

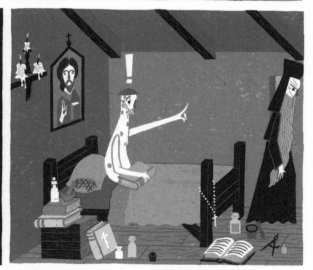

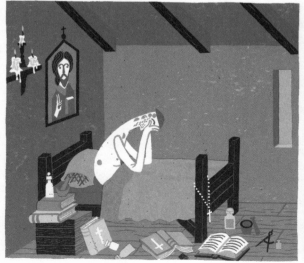

FIN

In the very beginning there were neither duvets nor algorithms. Only the wintery nippiness of Niflheim and the scorching sultriness of Muspelheim.

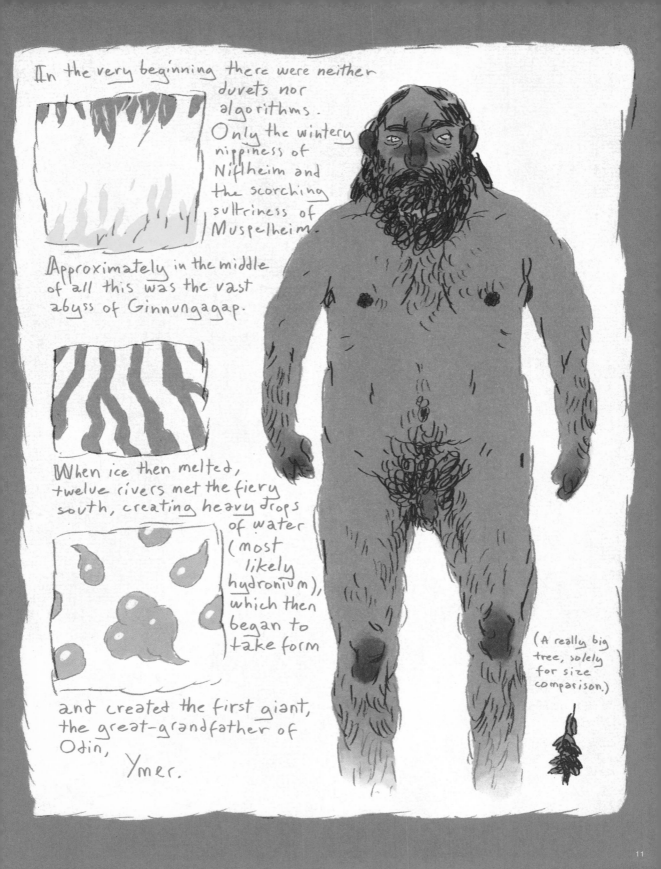

Approximately in the middle of all this was the vast abyss of Ginnungagap.

When ice then melted, twelve rivers met the fiery south, creating heavy drops of water (most likely hydronium), which then began to take form

and created the first giant, the great-grandfather of Odin, Ymer.

(A really big tree, solely for size comparison.)

11

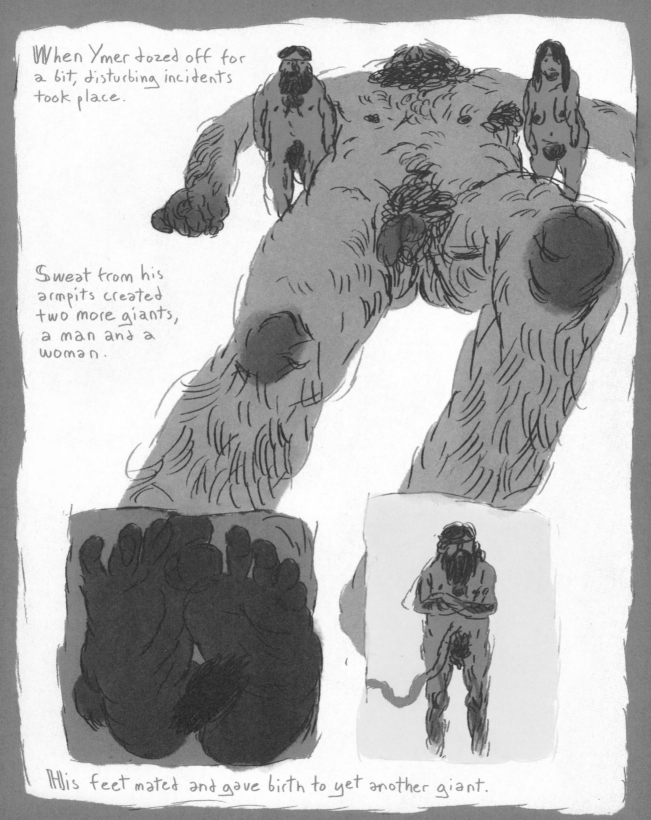

When Ymer dozed off for a bit, disturbing incidents took place.

Sweat from his armpits created two more giants, a man and a woman.

His feet mated and gave birth to yet another giant.

They all immediately started propagating...

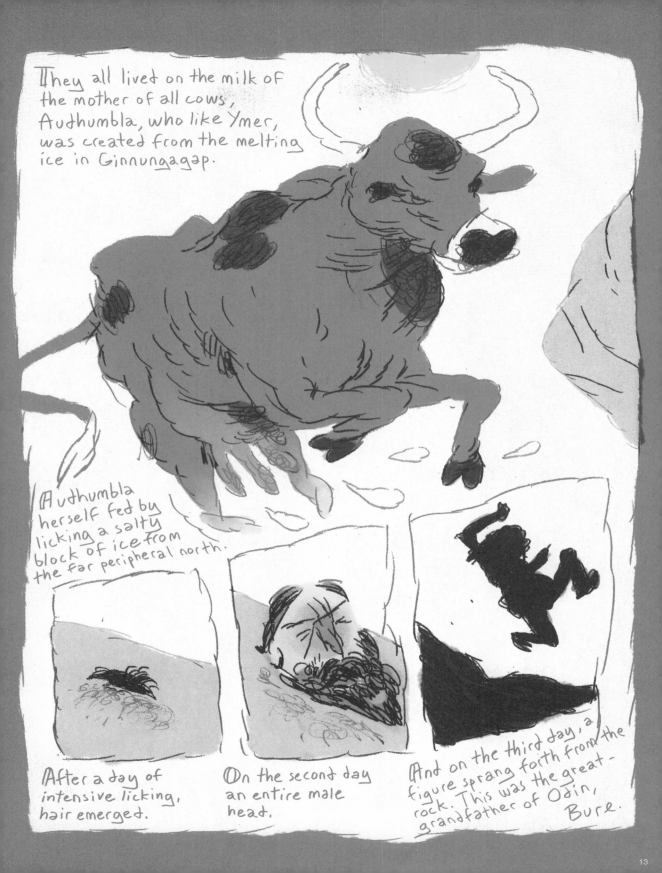

They all lived on the milk of the mother of all cows, Audhumbla, who like Ymer, was created from the melting ice in Ginnungagap.

Audhumbla herself fed by licking a salty block of ice from the far peripheral north.

After a day of intensive licking, hair emerged.

On the second day an entire male head.

And on the third day, a figure sprang forth from the rock. This was the great-grandfather of Odin, Bure.

Bure fathered Borr, and Borr fathered three sons, the gods Vile, Ve and Odin.

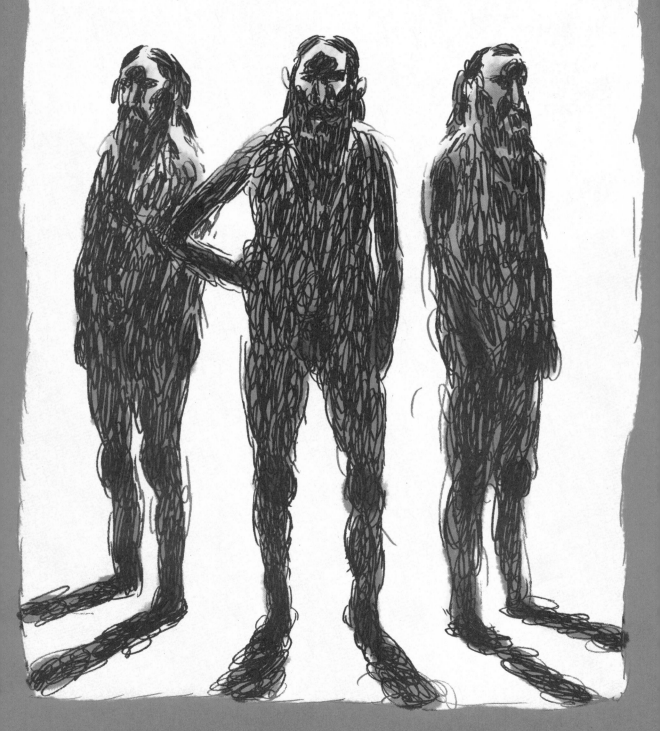

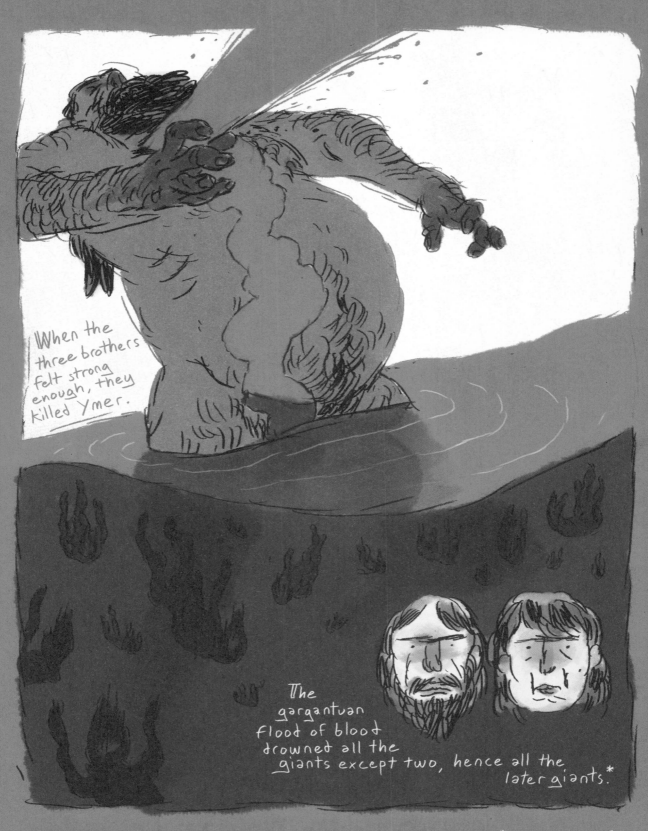

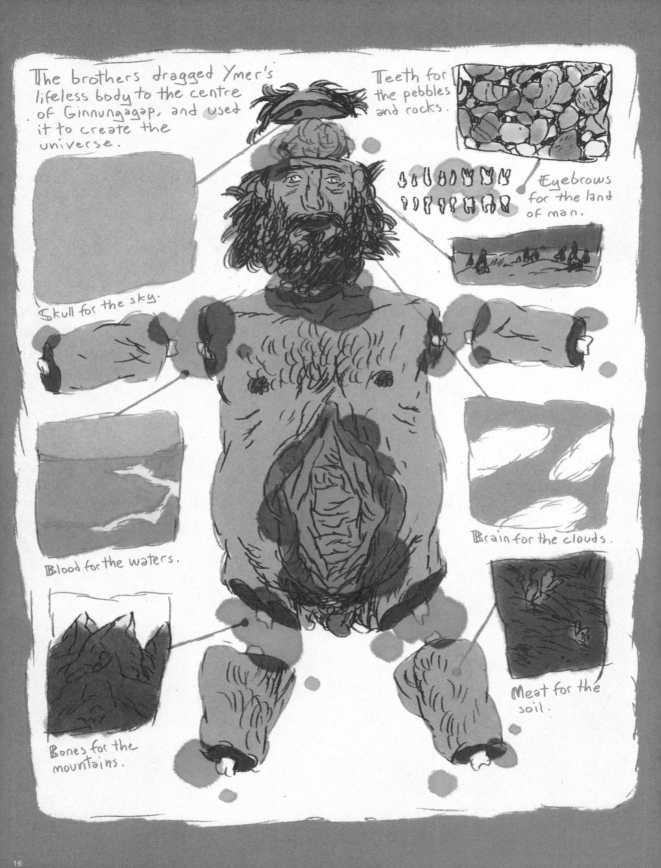

The brothers dragged Ymer's lifeless body to the centre of Ginnungagap, and used it to create the universe.

Teeth for the pebbles and rocks.

Eyebrows for the land of man.

Skull for the sky.

Blood for the waters.

Brain for the clouds.

Bones for the mountains.

Meat for the soil.

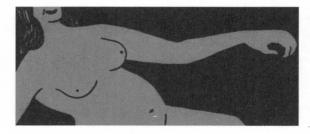

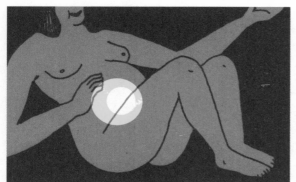

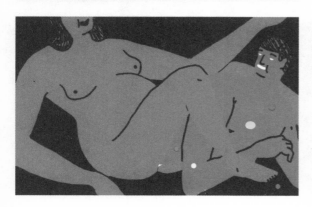
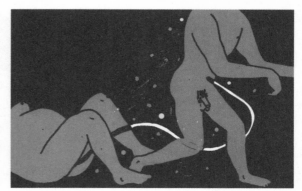

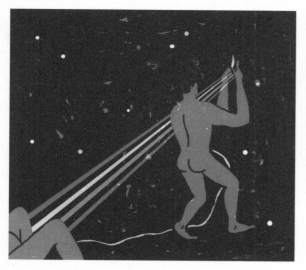
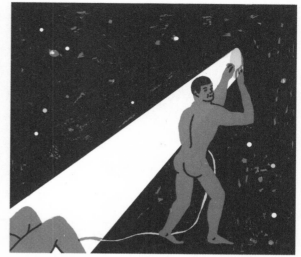

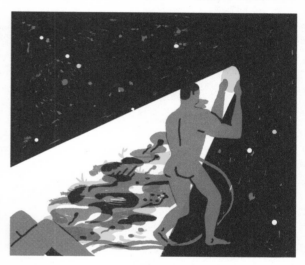
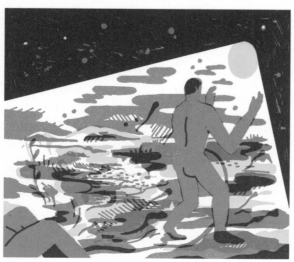
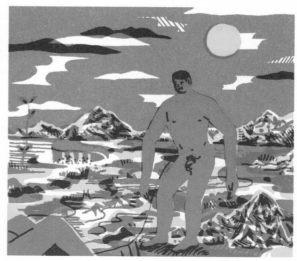

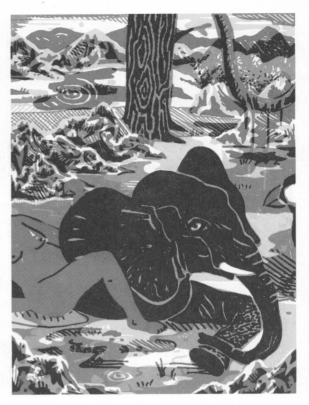
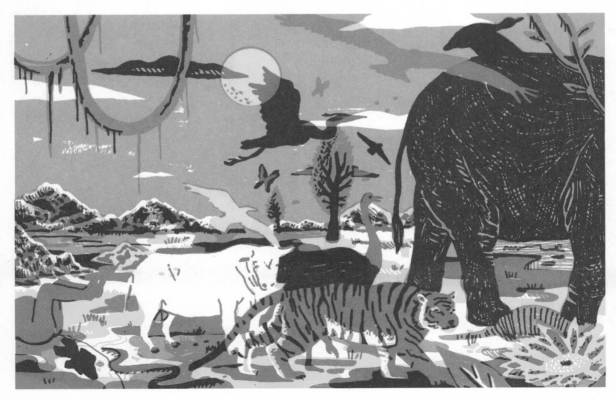

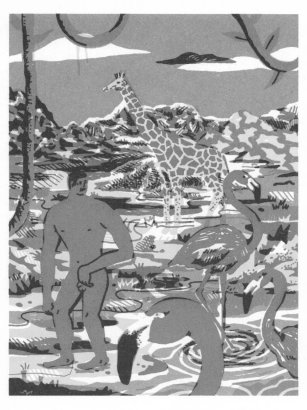
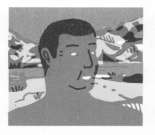
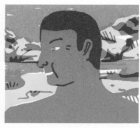
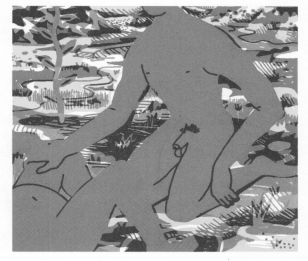
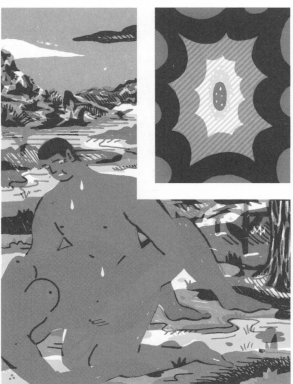
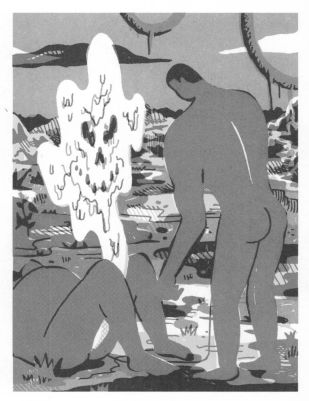

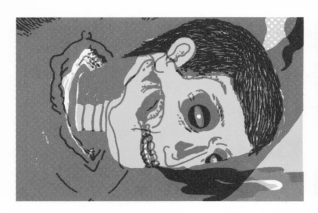

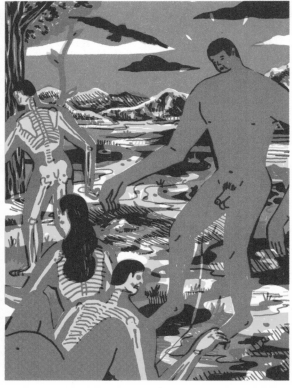
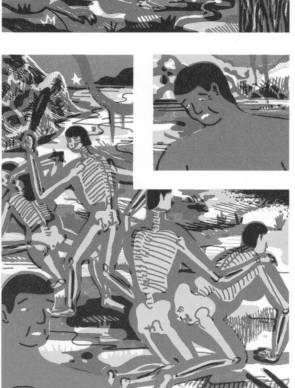
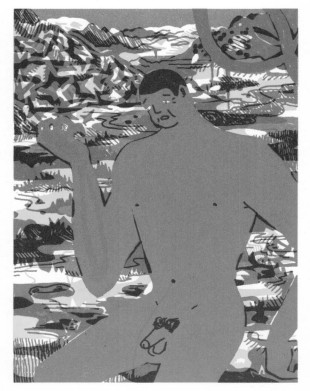

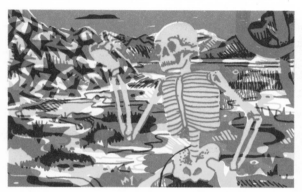
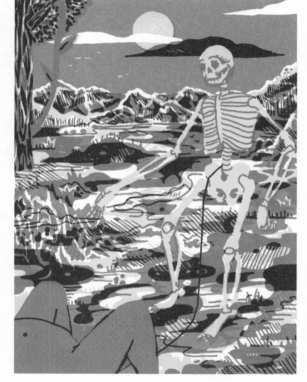
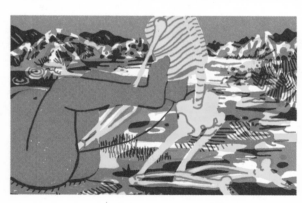
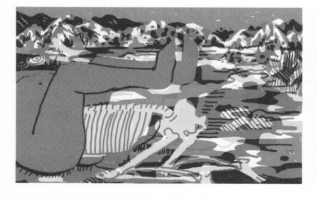
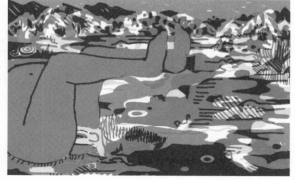

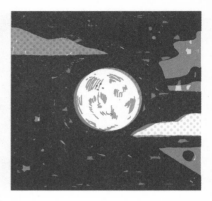
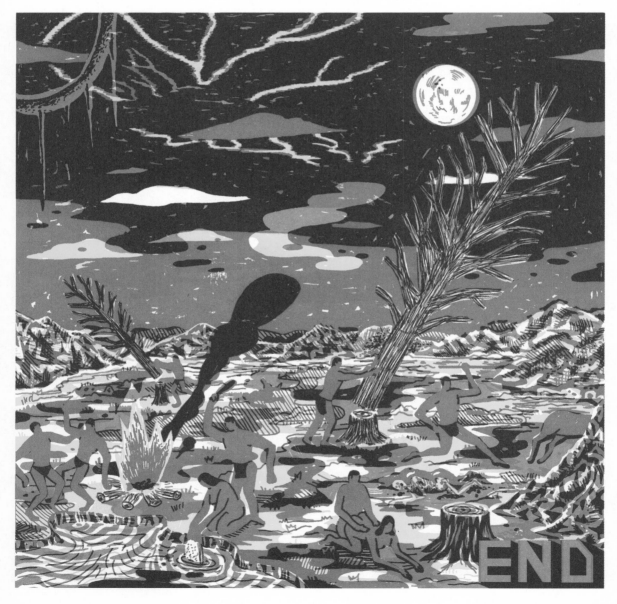

E N O D

BY LUKE BEST

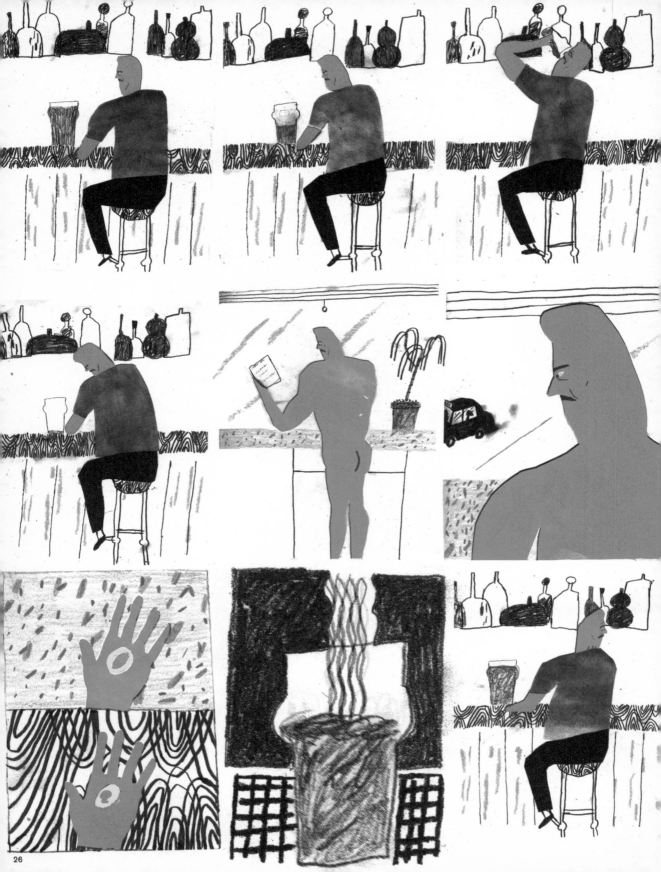

and then its back to the same fucking thing 'what happened to your drive?' Dont you have any ambition?'

As though I dont do anything? what? I mean, just what does she think I do EVERYDAY?

So you know what I say?

I look Her UP and DOWN and say your right, if I had ANY ambition I wouldnt of Settled for A SACK of SHIT

Ha Ha yeah what dshe hav to say to that? huh? Thats Right! Fuck all! not a fuckin thing! yeah thats what She Said

nothing

27

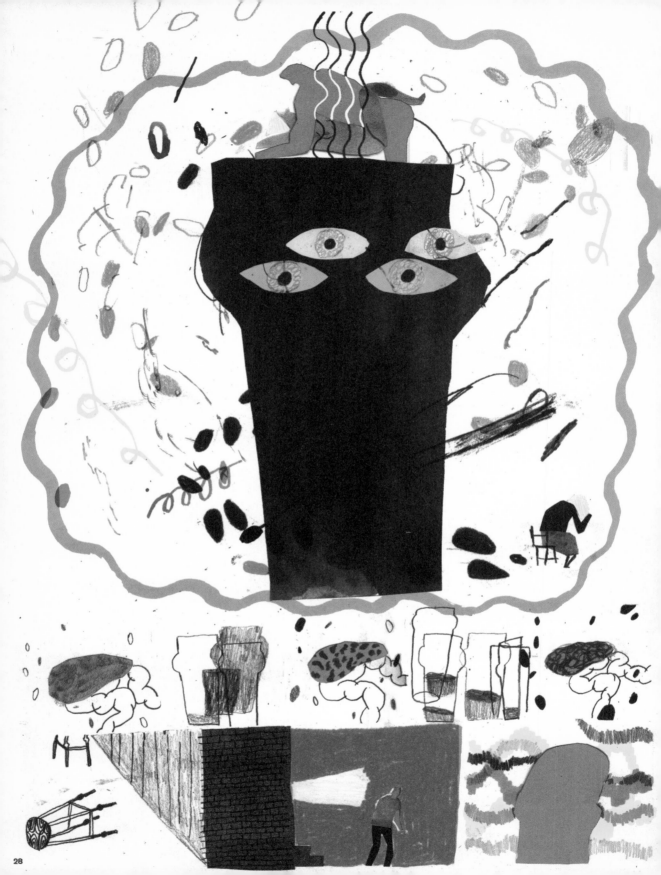

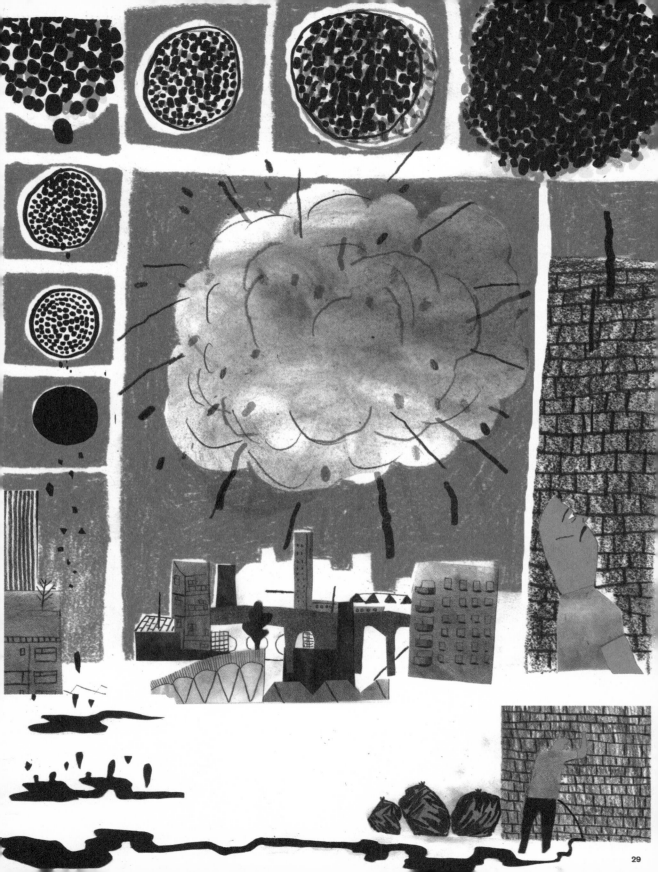

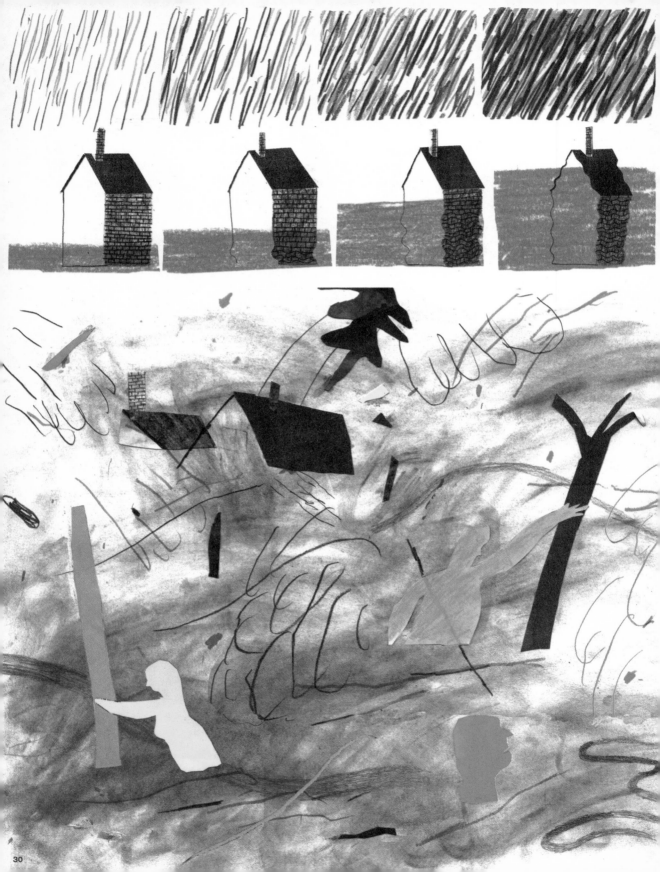

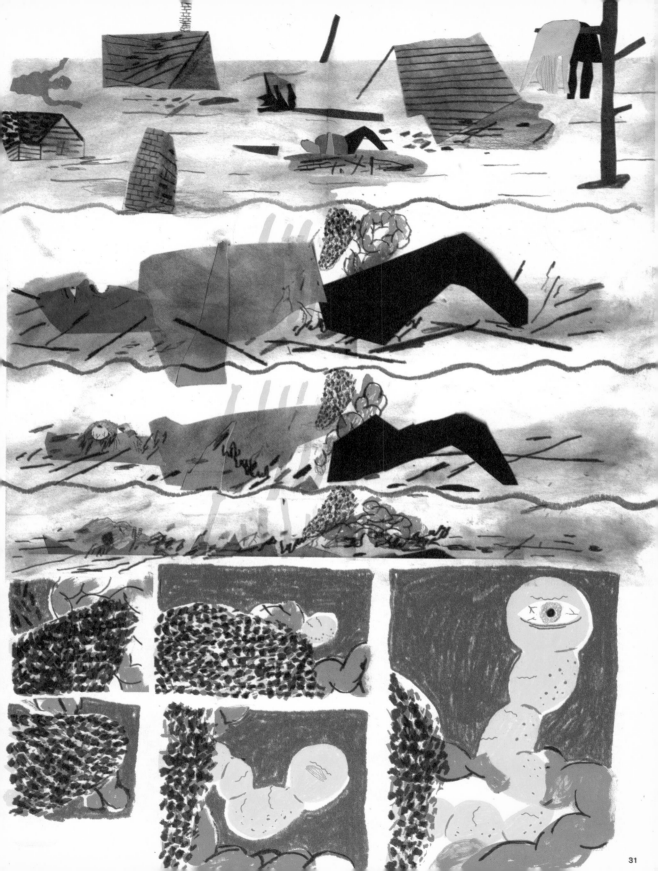

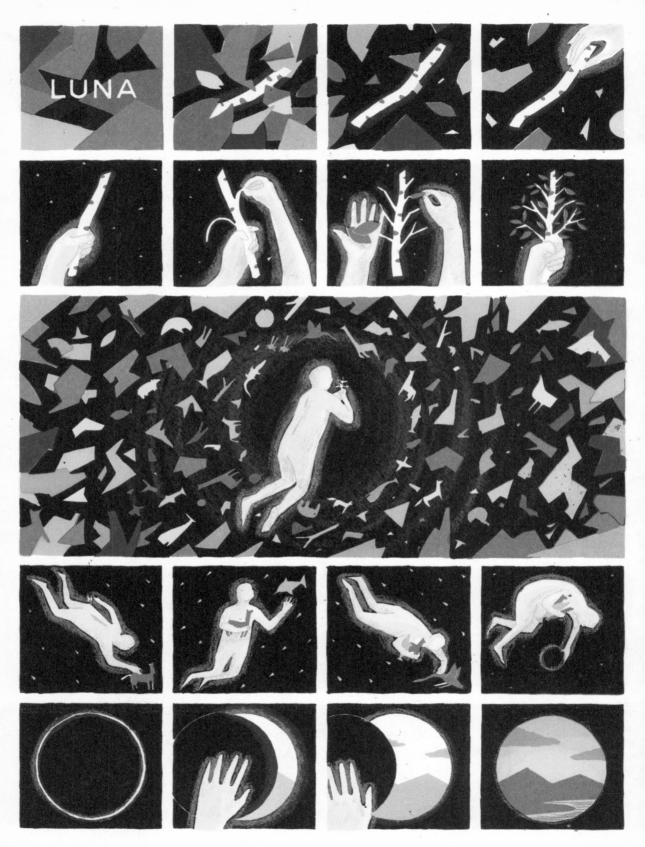

LUNA

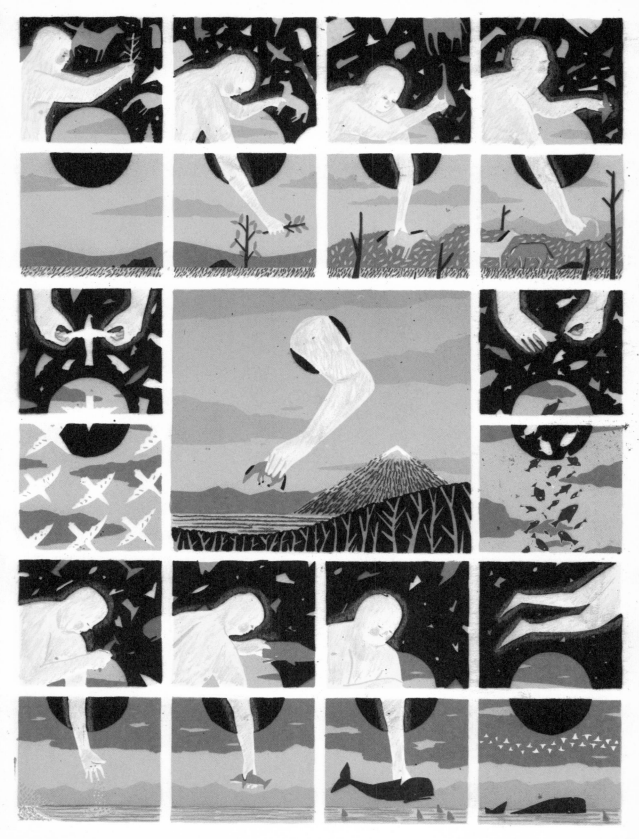

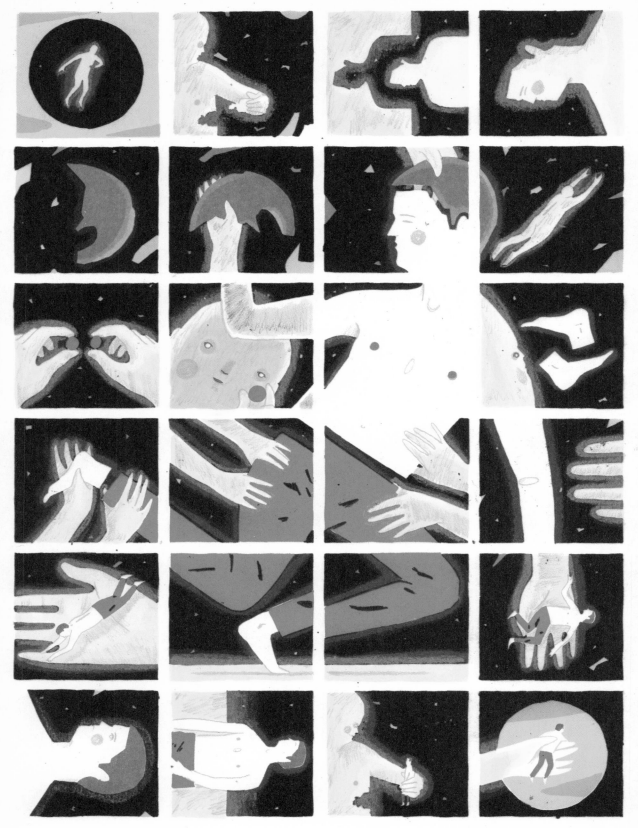

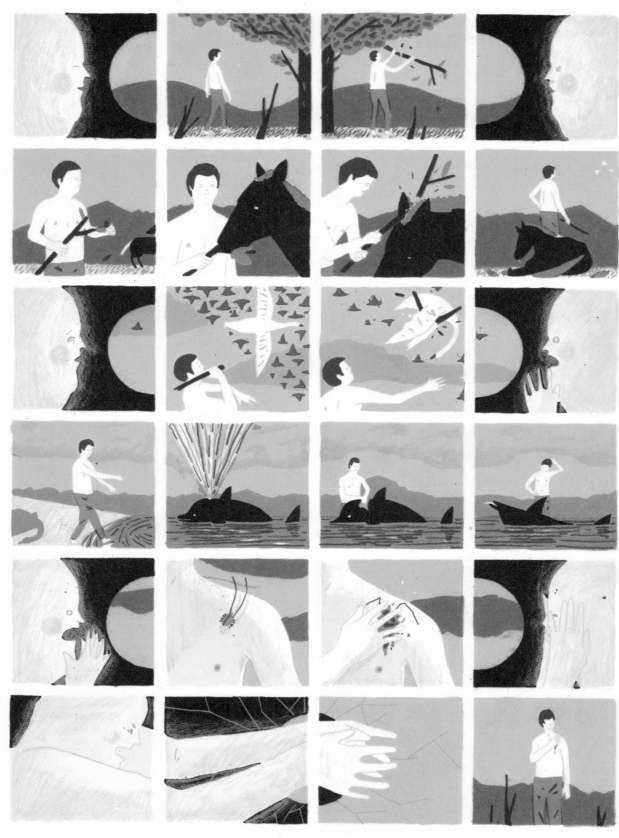

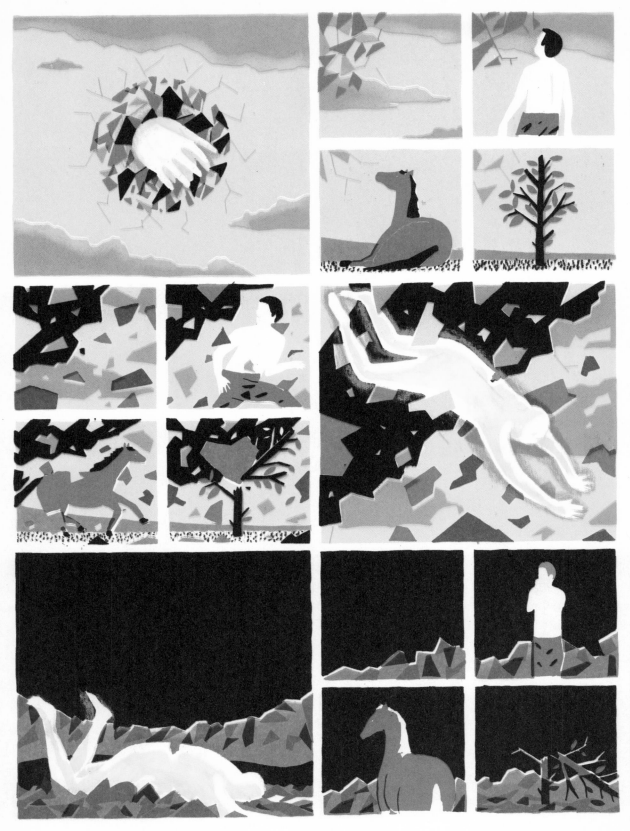

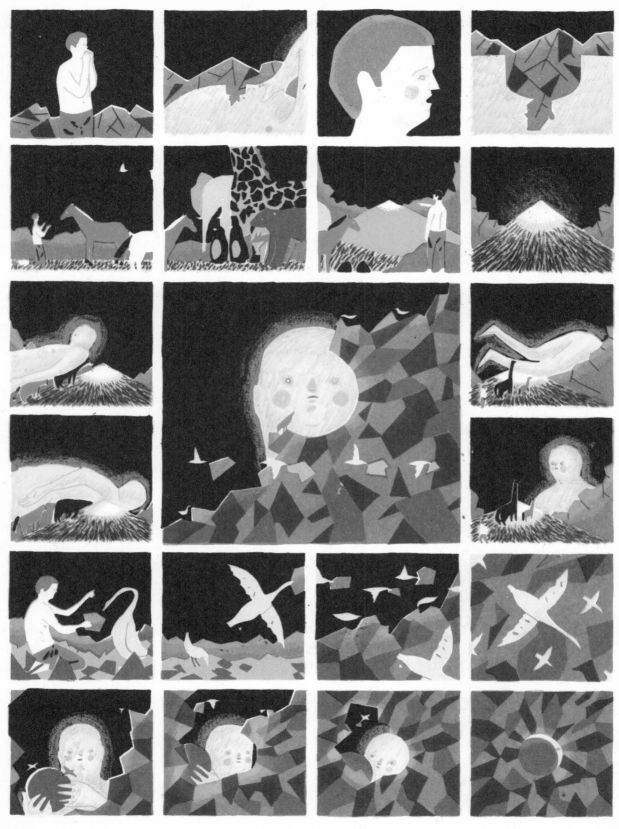

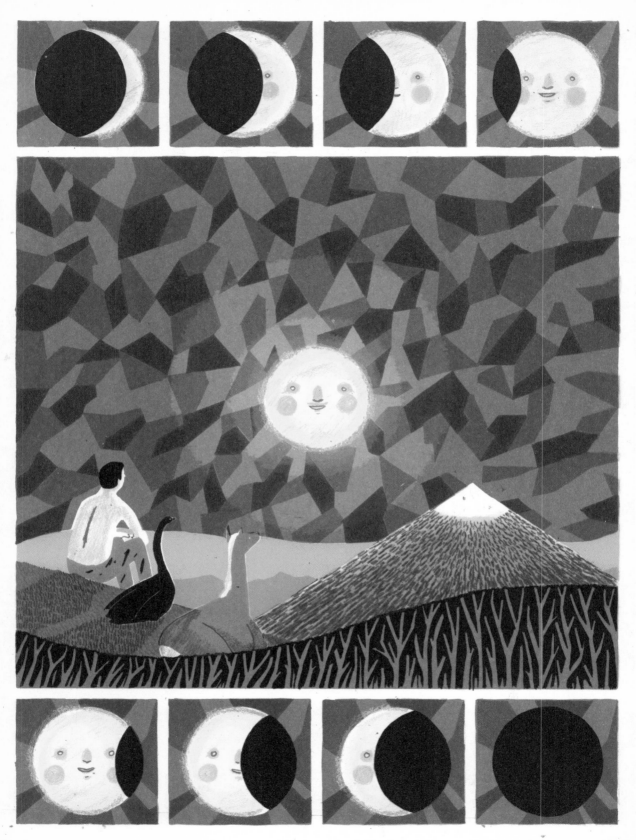

PILGRIMS

Jon McNaught

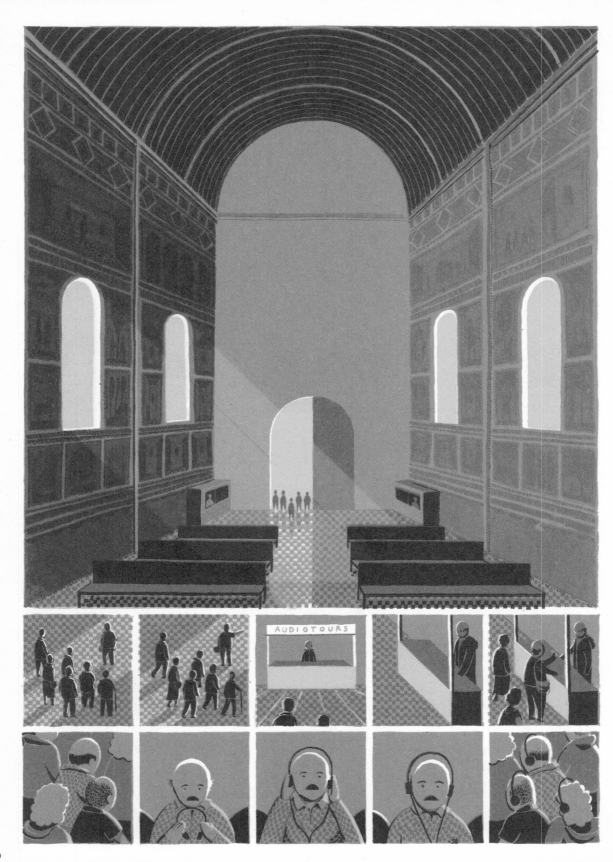

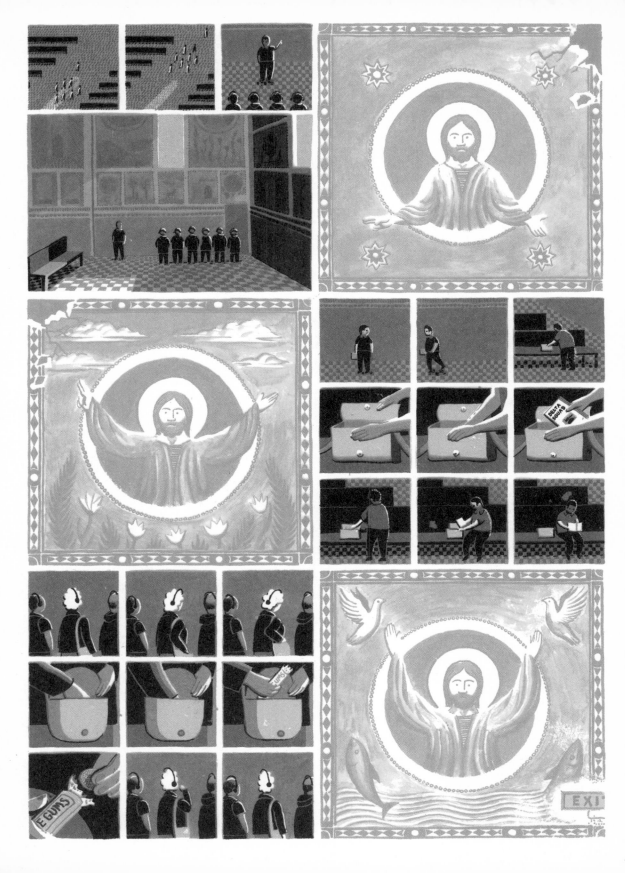

41

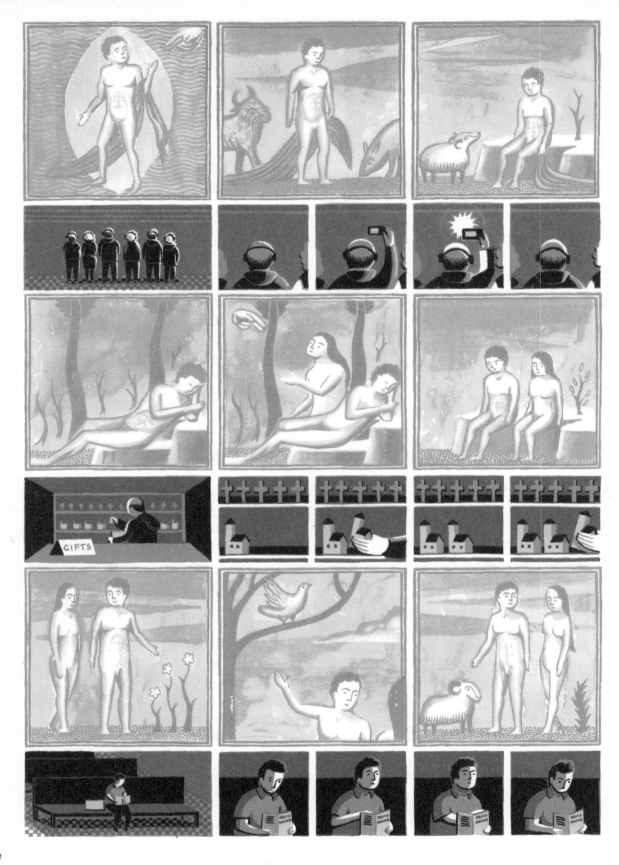

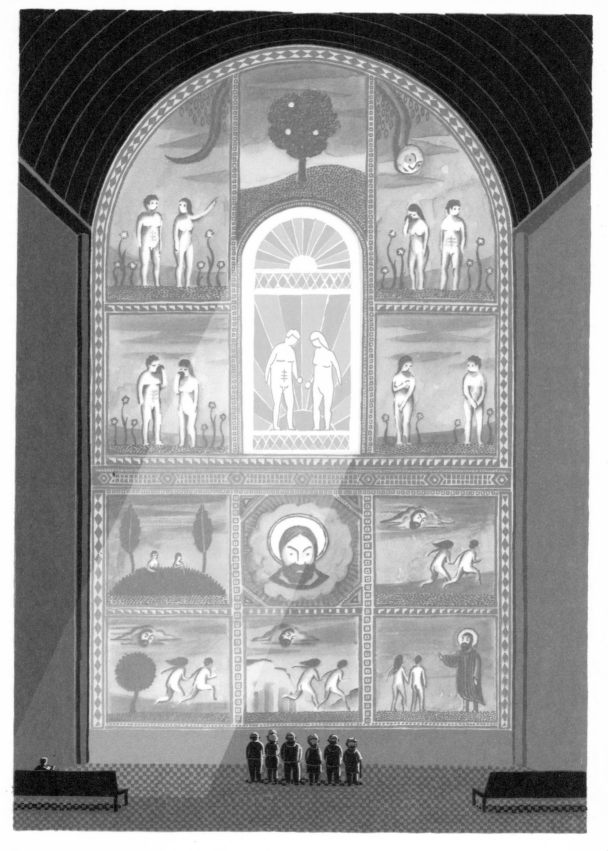

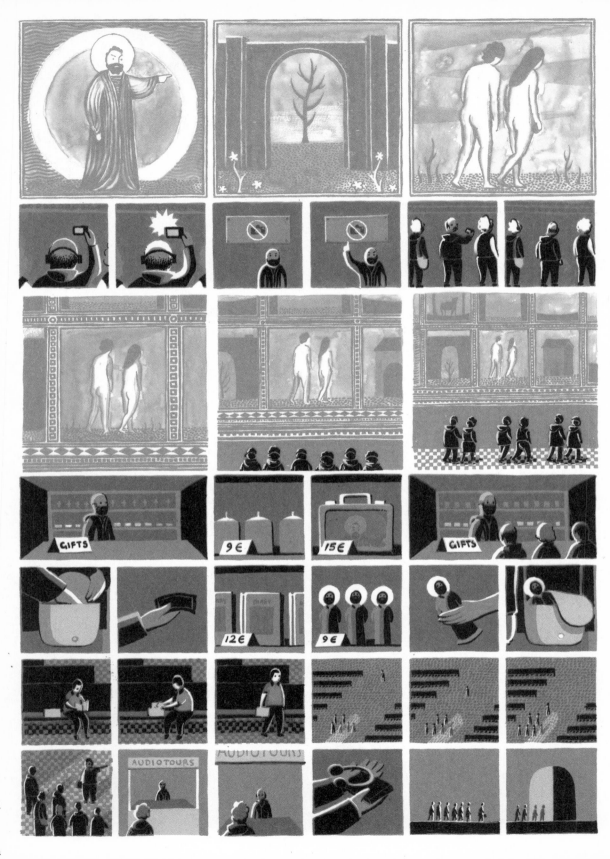

END

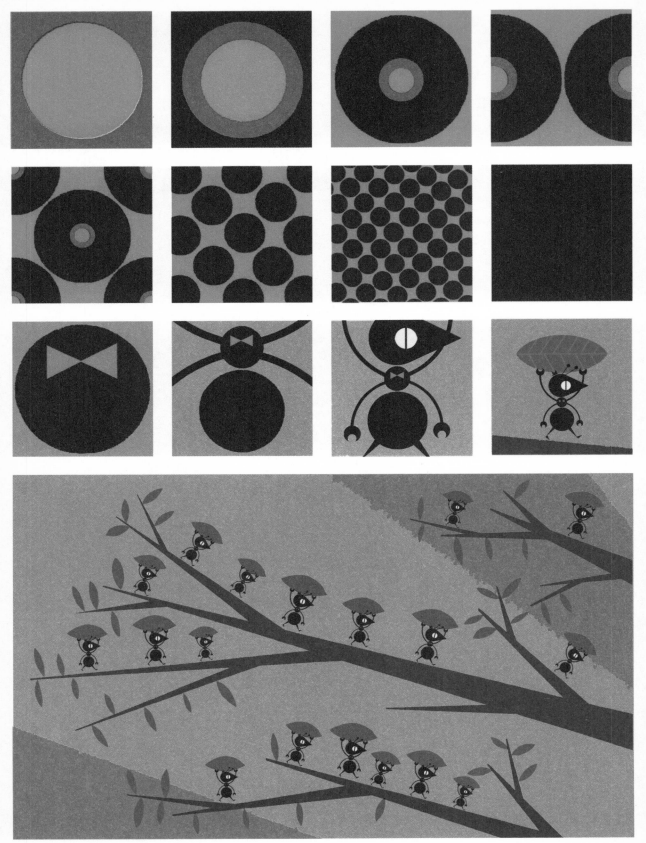

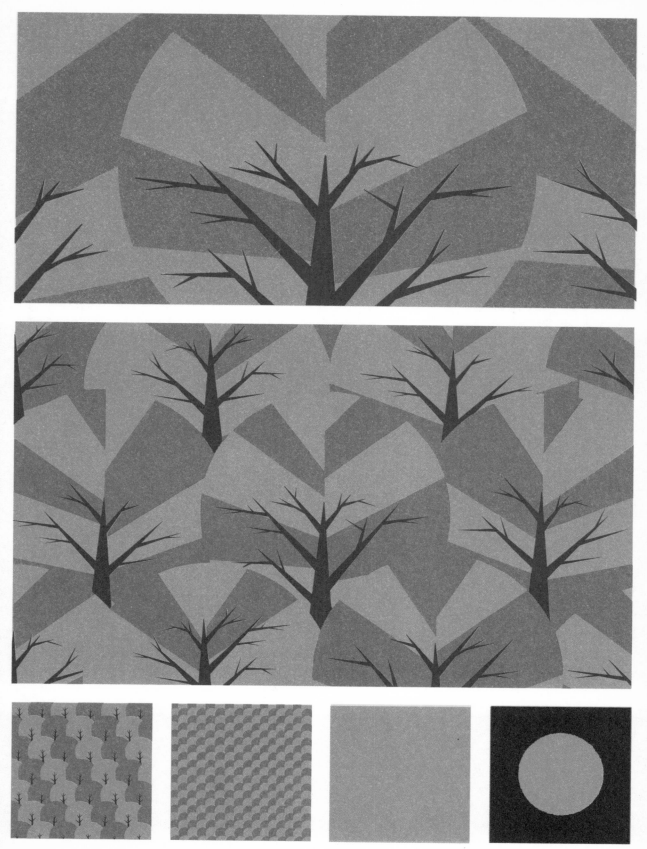

47

49

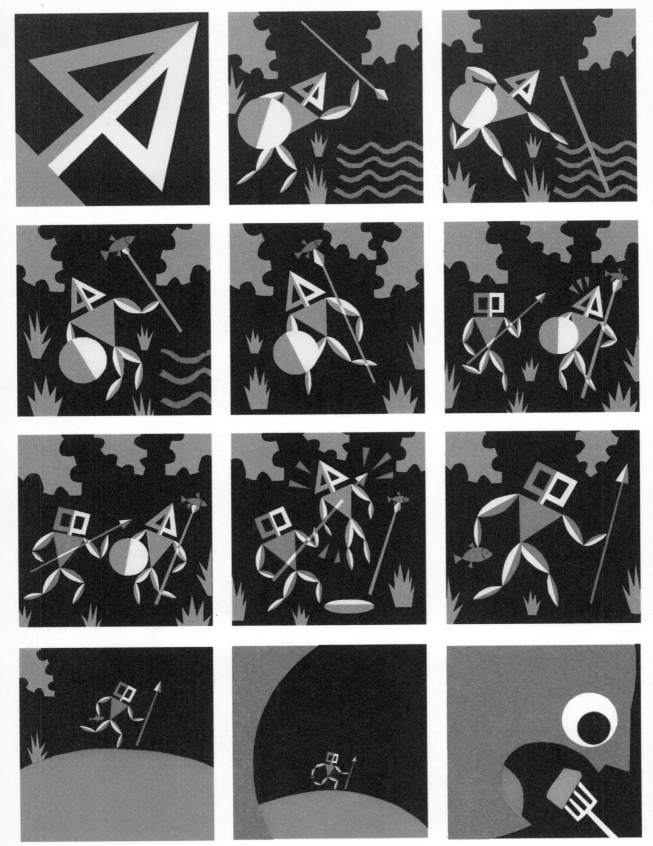

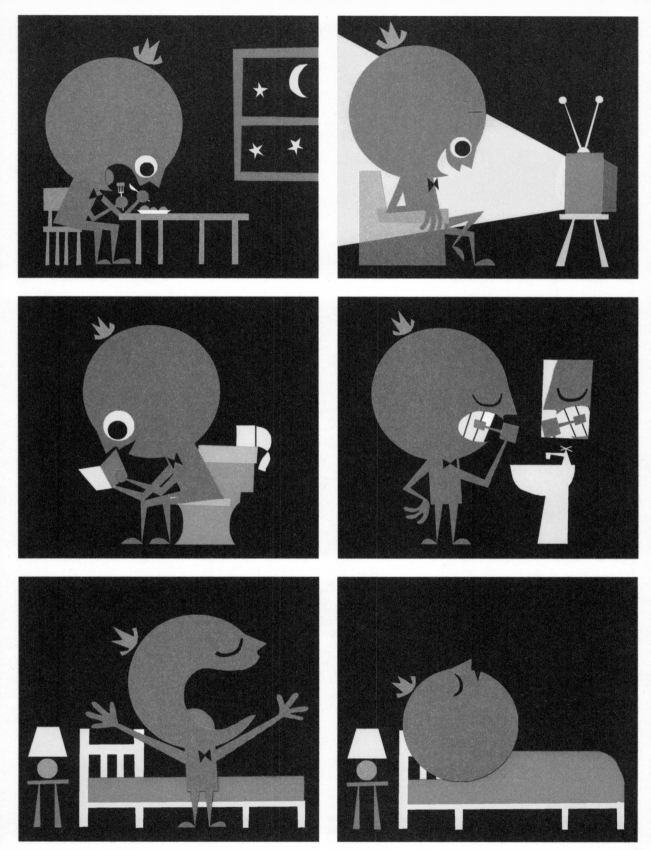

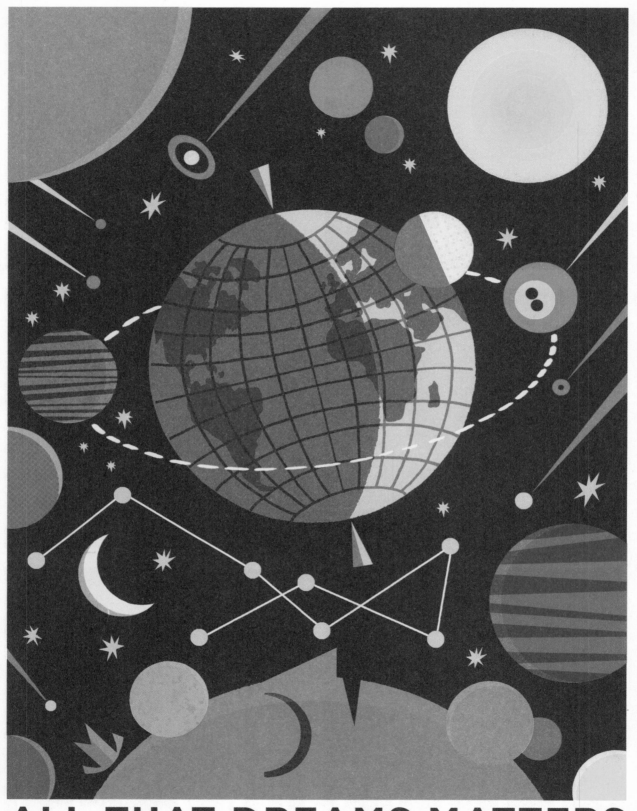

ALL THAT DREAMS MATTERS

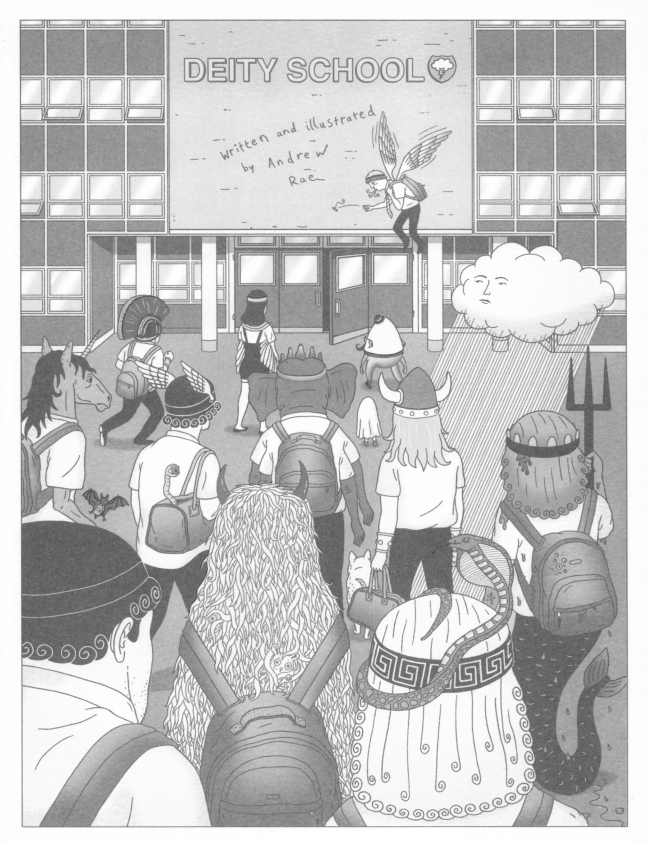

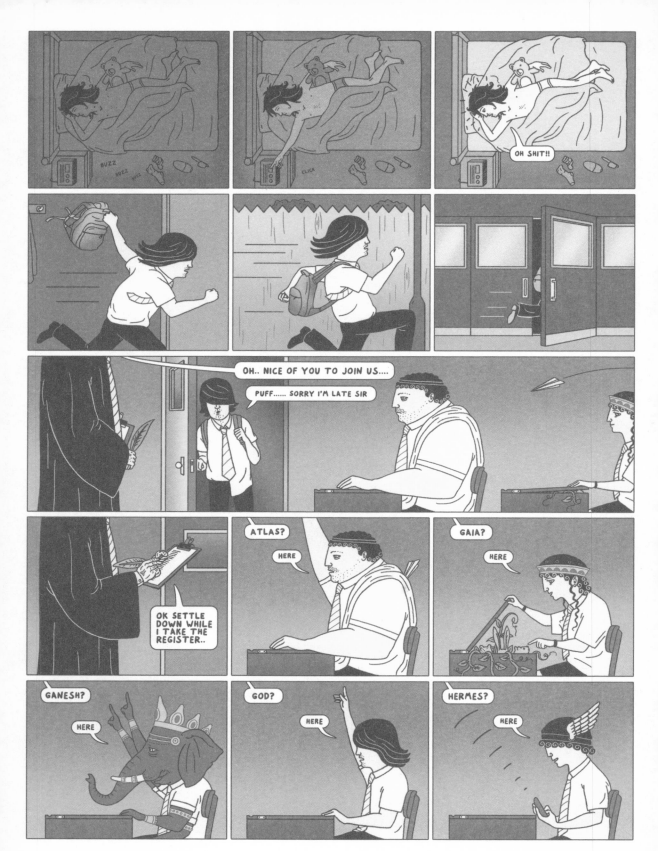

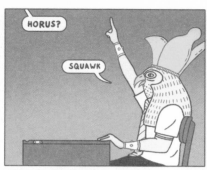

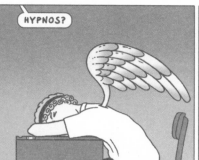

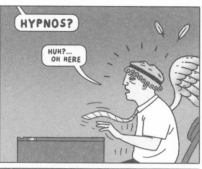

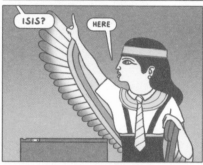

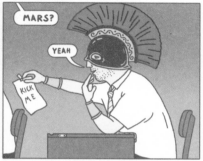

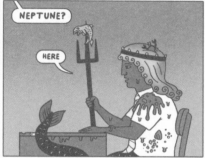

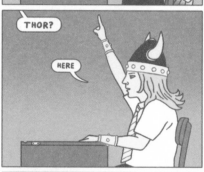

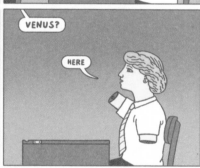

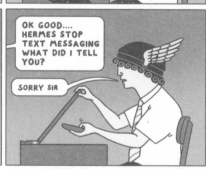

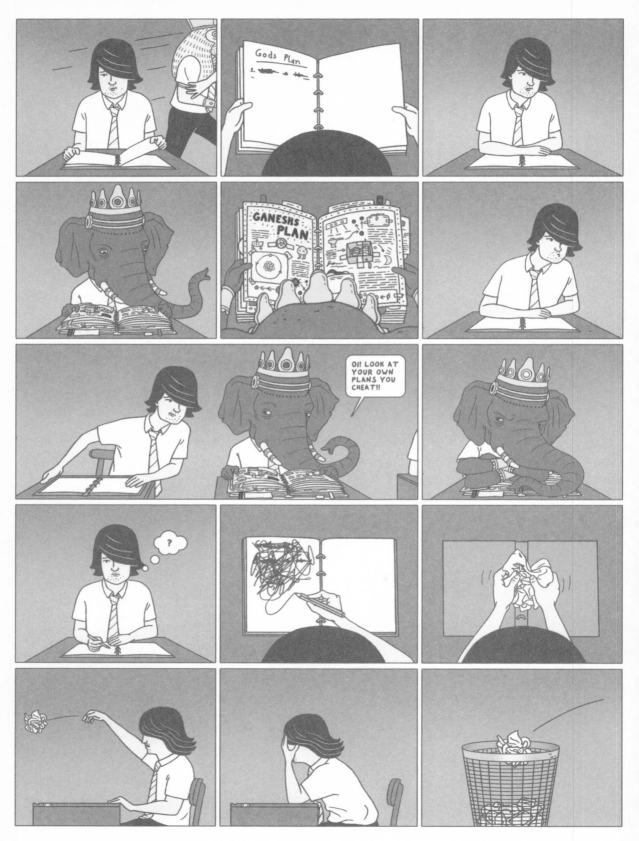

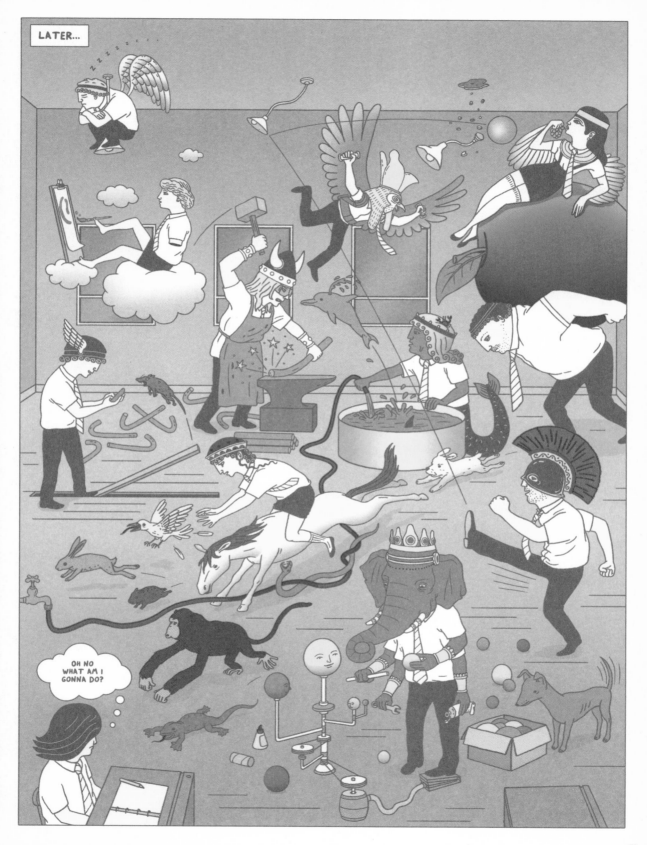

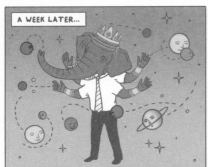
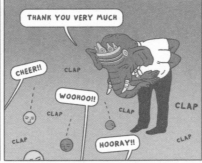

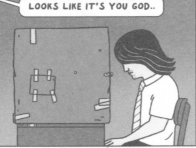
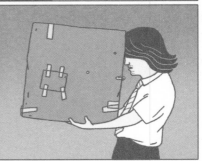
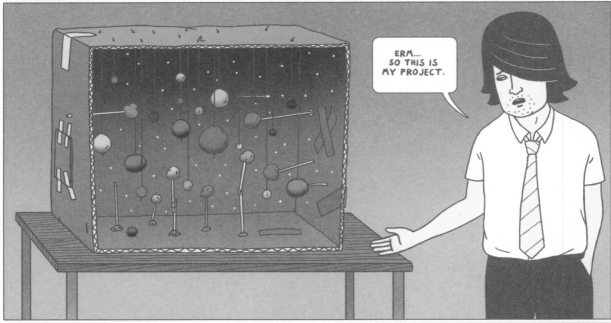

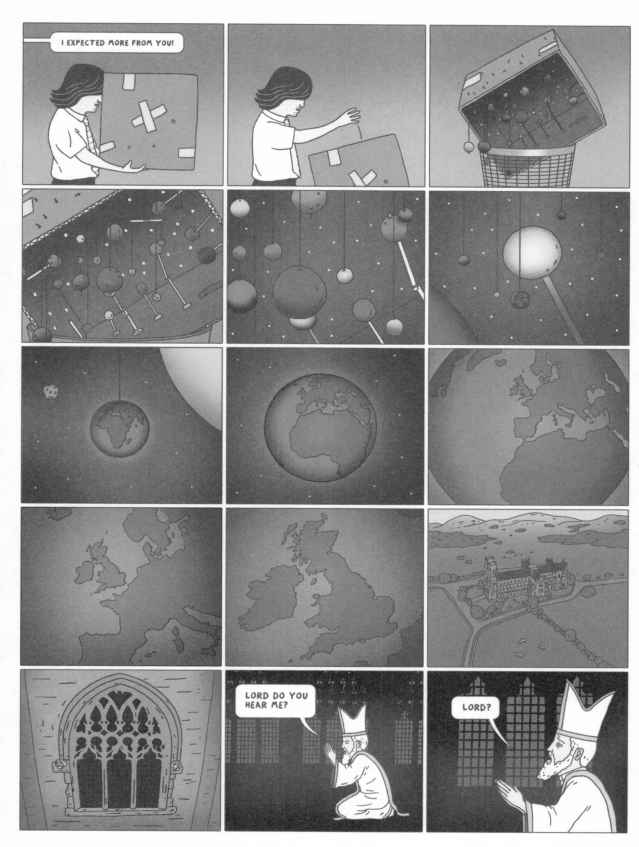

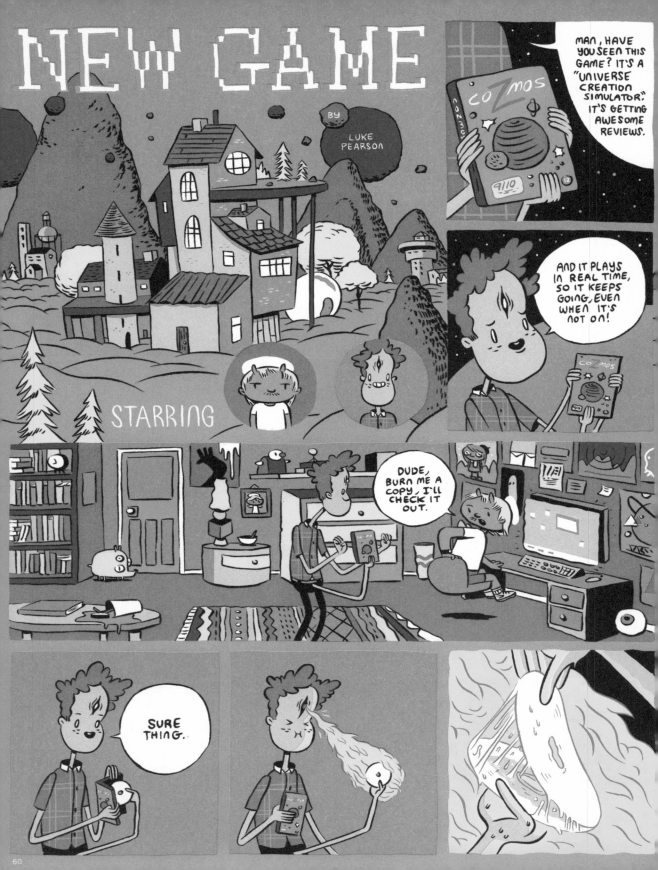

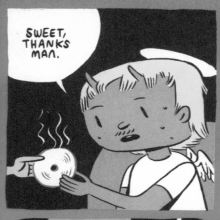

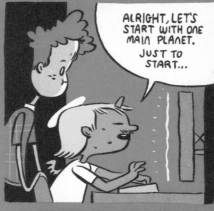

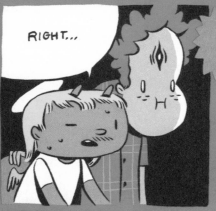

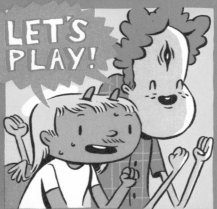

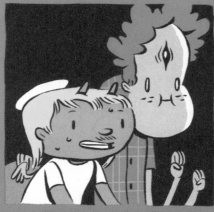

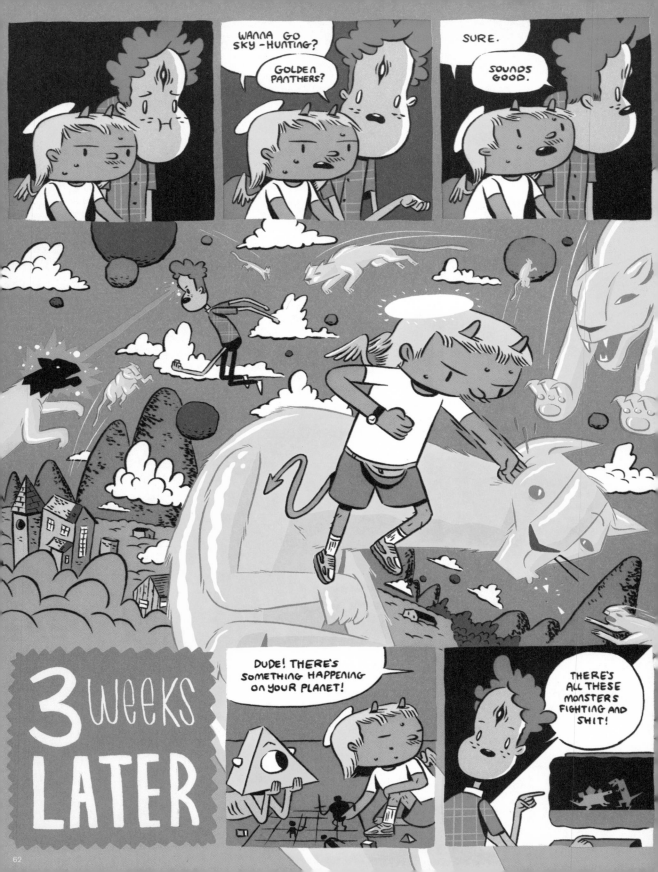

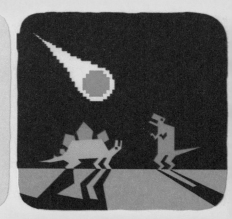

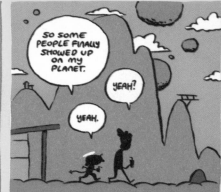

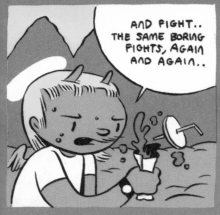

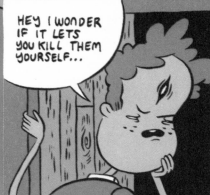

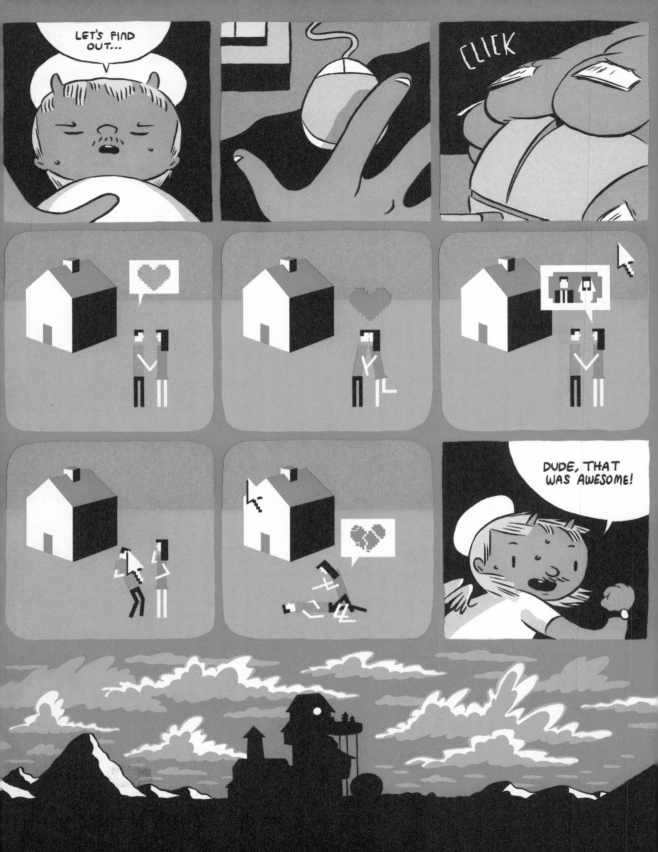

eventually

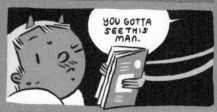
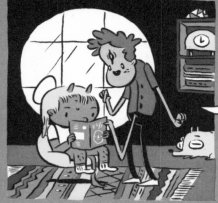
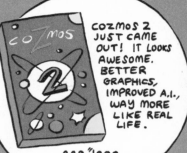

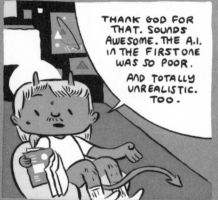
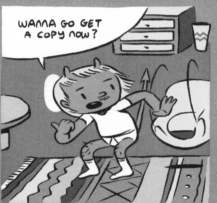
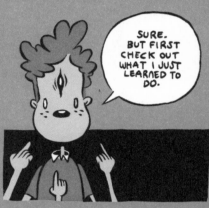

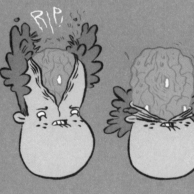
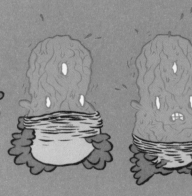

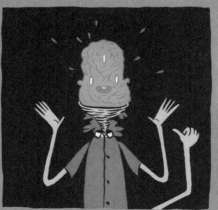

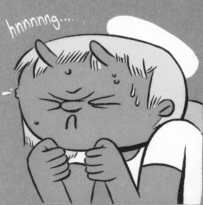

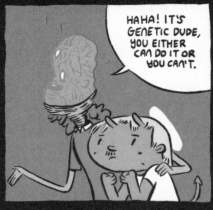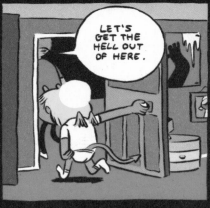

PLANET NAME: EARTH
USER: GODFREY616

VIRTUAL TIME PLAYED:
4,540,000,000 y. 11 m.
2 w. 5 d. 26 m. 03 s.

REAL TIME PLAYED:
3 m. 1 w. 3 d. 45 m.
21 s.

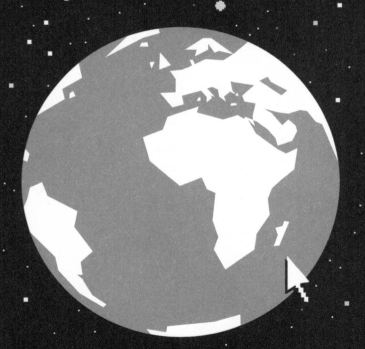

MENU
OPTIONS
SAVE
LOAD
QUIT

THE END

DUST TO DUST

BY JACK TEAGLE

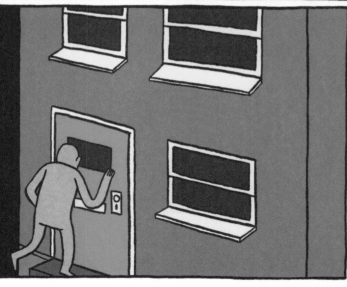

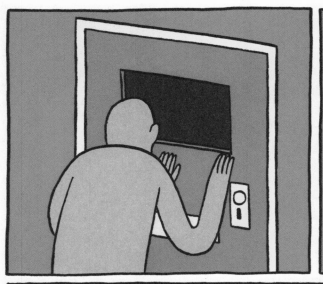
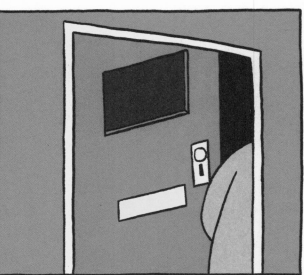
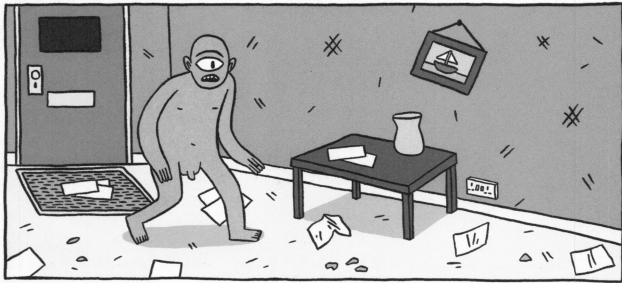
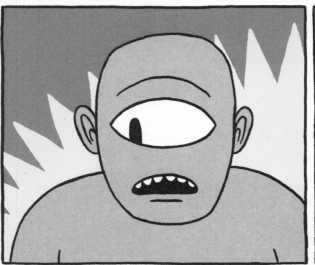
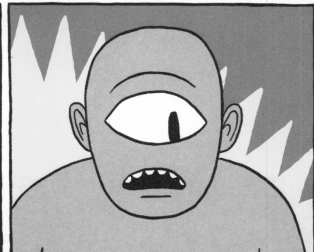

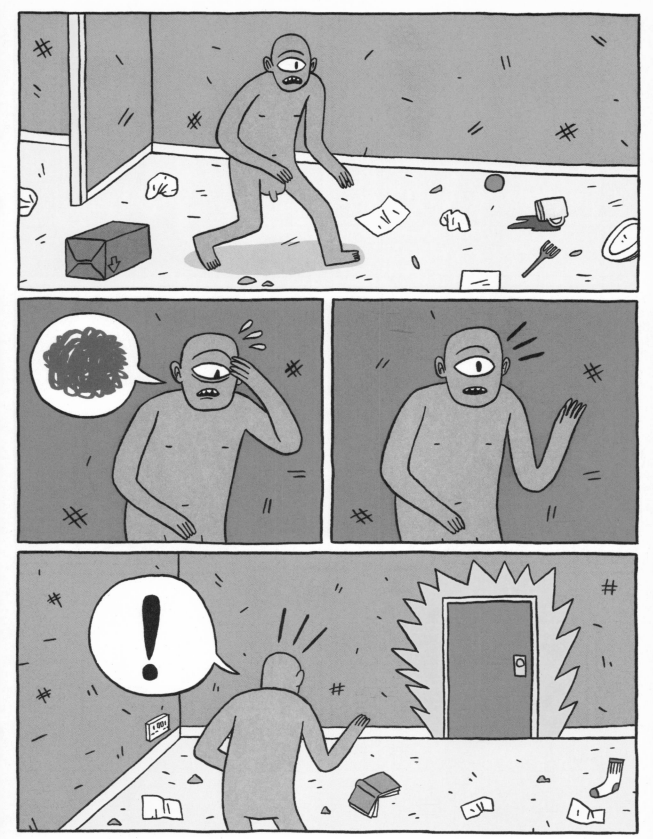

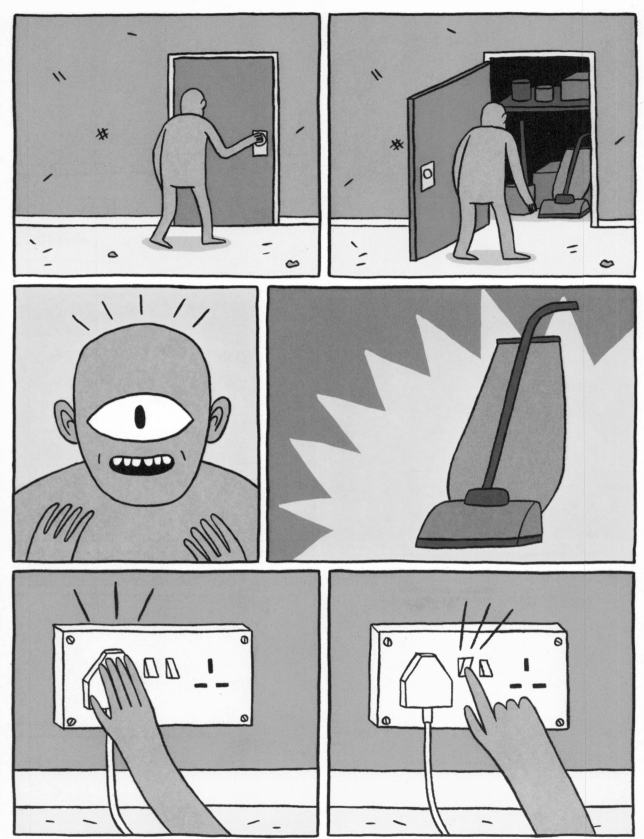

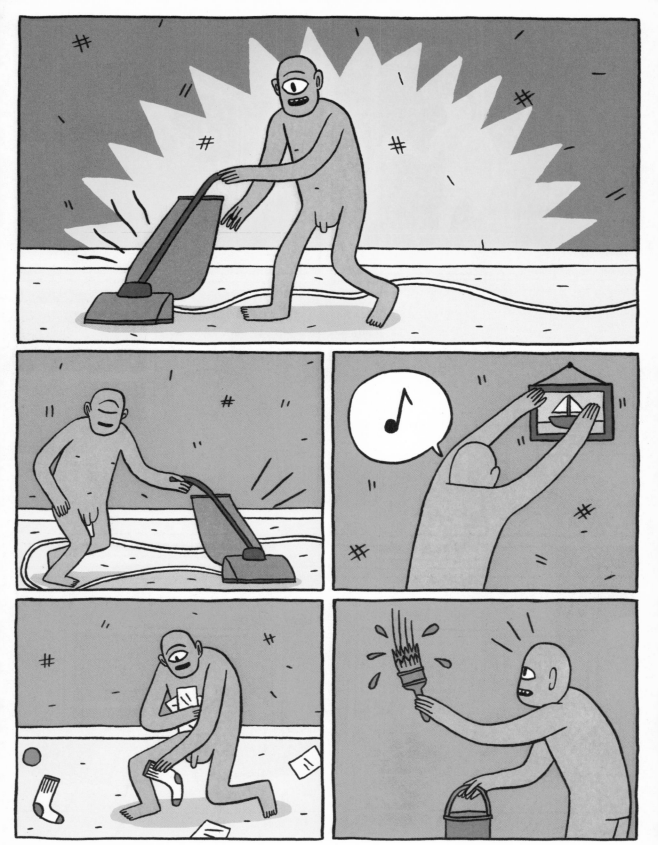

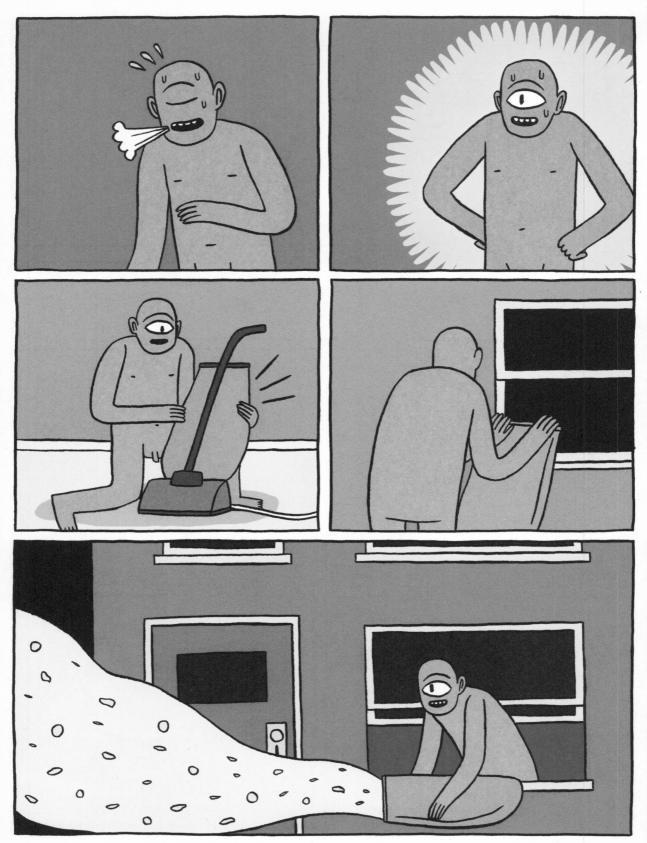

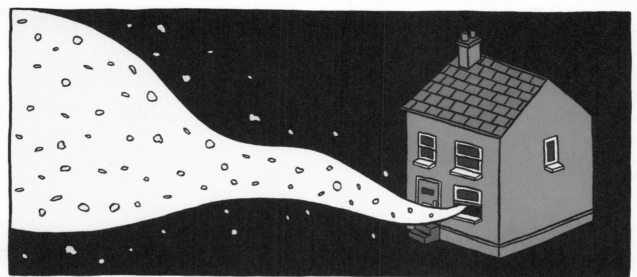

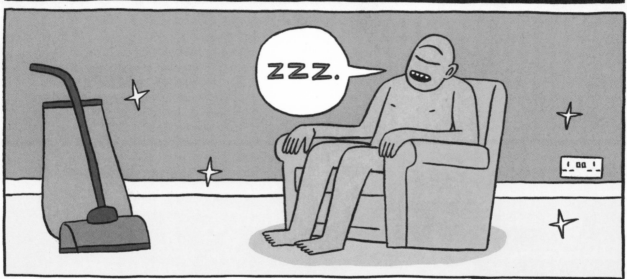

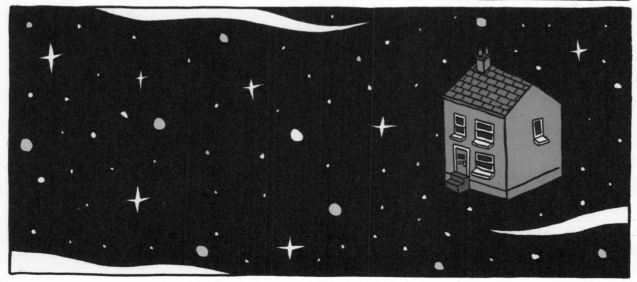

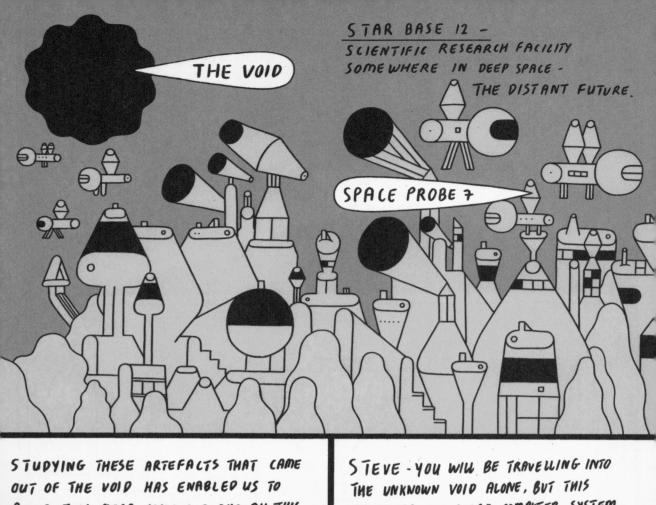

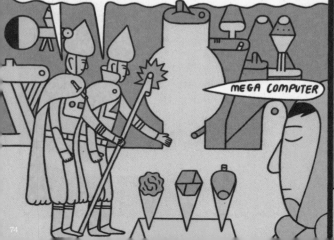

STUDYING THESE ARTEFACTS THAT CAME OUT OF THE VOID HAS ENABLED US TO BUILD THIS MEGA COMPUTER AND ALL THIS COOL FUTURISTIC SHIT.

NOW YOU MUST GO ON A DANGEROUS MISSION INTO THE VOID AND BRING BACK MORE AWESOME STUFF FOR US TO STUDY.

MEGA COMPUTER

STEVE - YOU WILL BE TRAVELLING INTO THE UNKNOWN VOID ALONE, BUT THIS ADVANCED ON-BOARD COMPUTER SYSTEM SHOULD BE ABLE TO KEEP YOU ALIVE.

NOW - GO BRING US BACK SOME MEGA TECHNOLOGY!

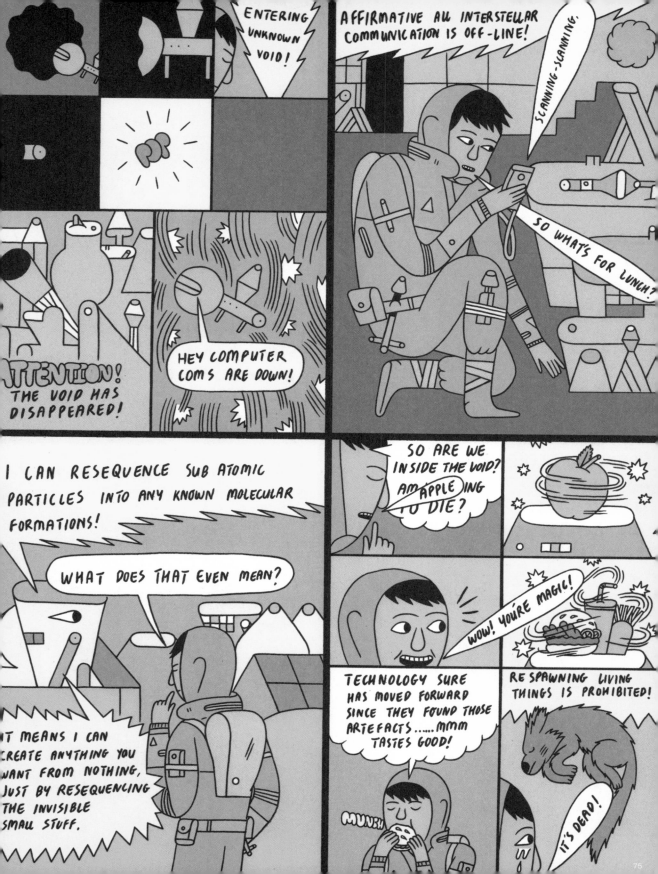

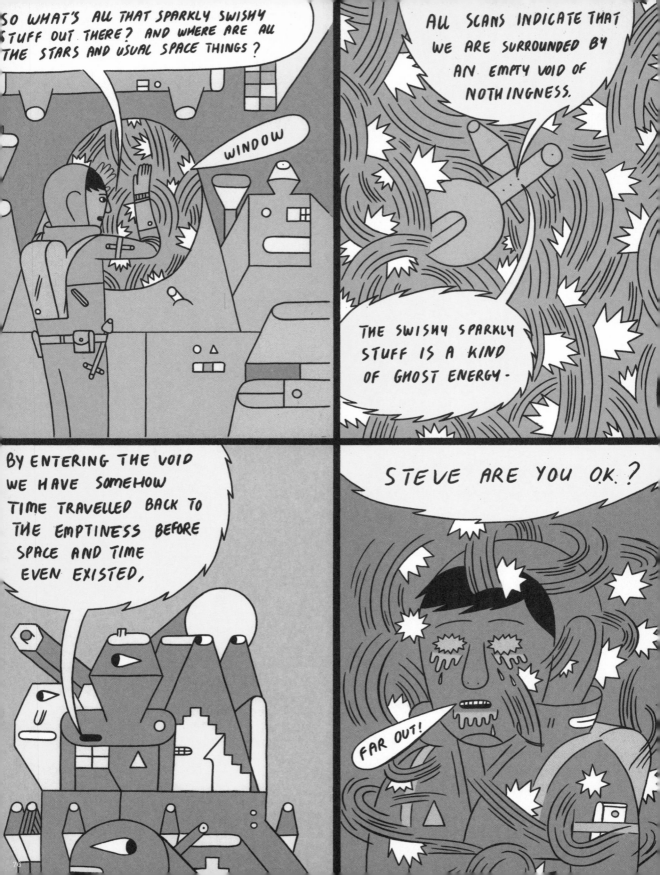

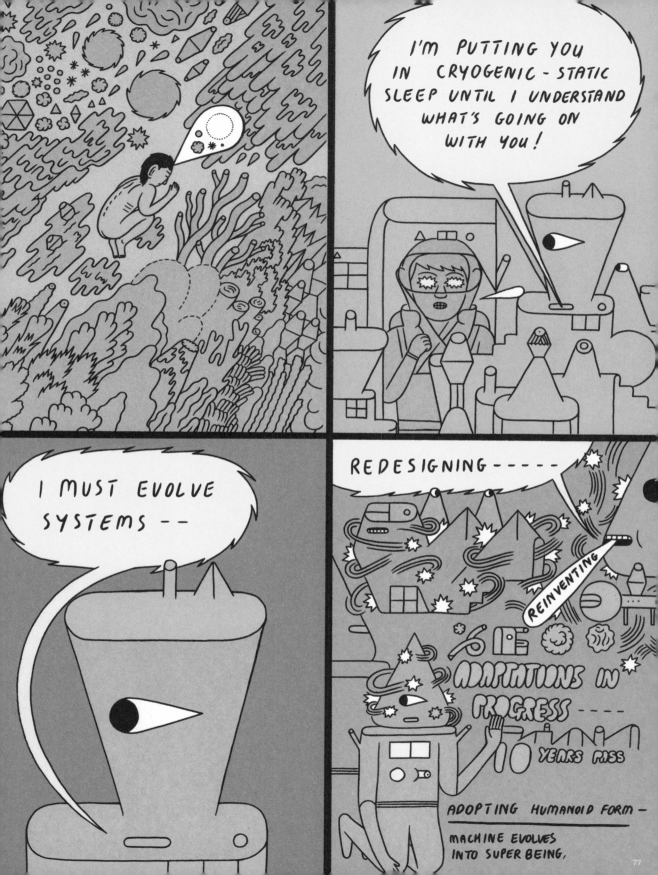

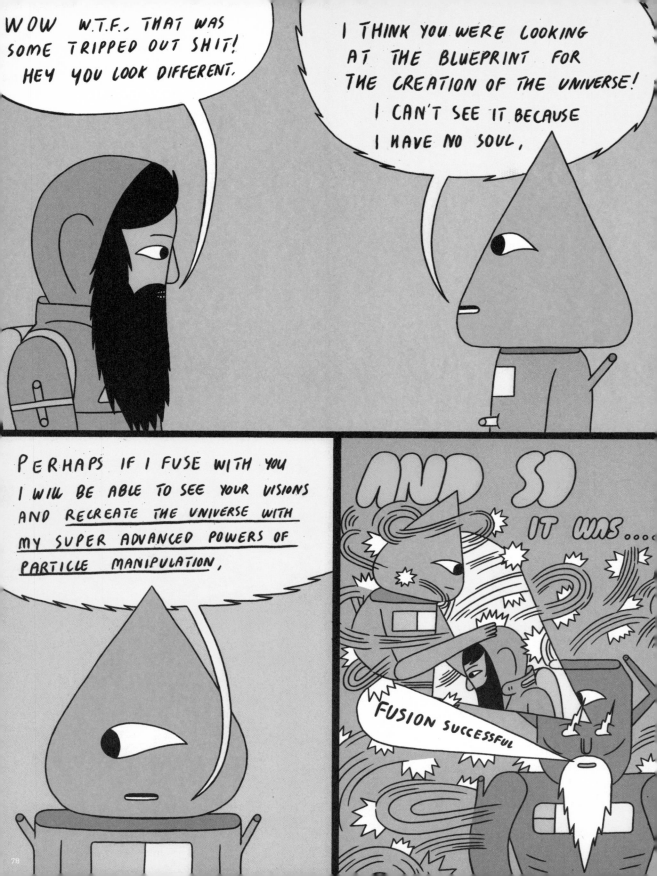

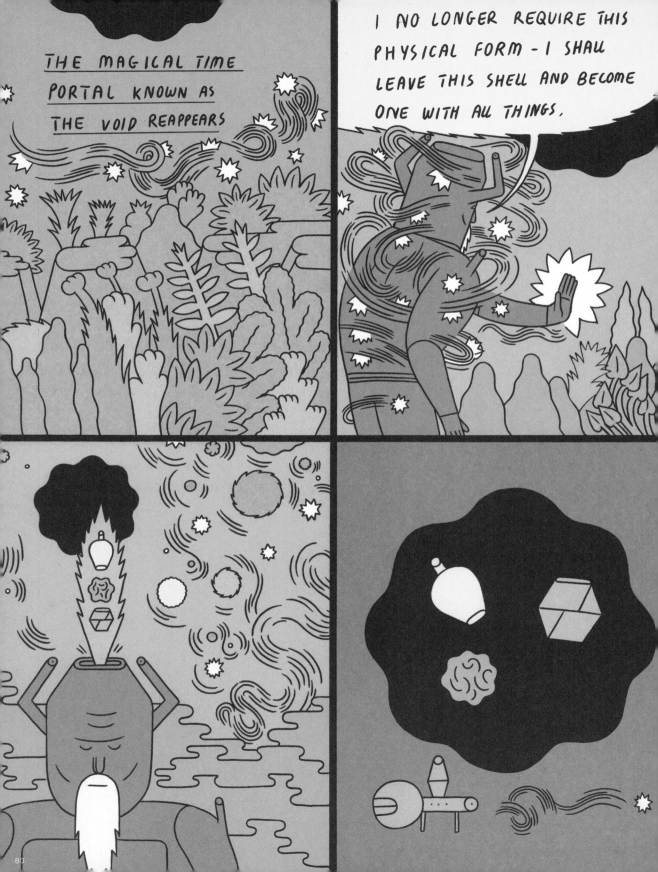

THE WOLRD MUST BE DESTROYED!

by JAKOB HINRICHS

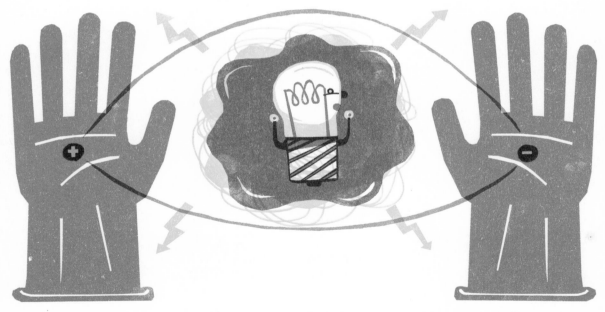

1 First MAN created the CYCLOVERSE. 2 The CYCLOVERSE was without form and void, and darkness was upon the face of the deep. 3 And MAN said, "Let there be LIGHT"; and there was light. 4 And MAN saw the light, that it was good; and MAN separated the light from the darkness. 5 MAN called the light ON, and the darkness he called OFF. And there was evening and there was morning, one DAY. 6 And MAN said, "Let there be a SPHERE in the midst of the waters, and let it separate the waters from the waters." 7 And MAN made the SPHERE and separated the

THE GREAT LIGHT WILL RULE THE ON!

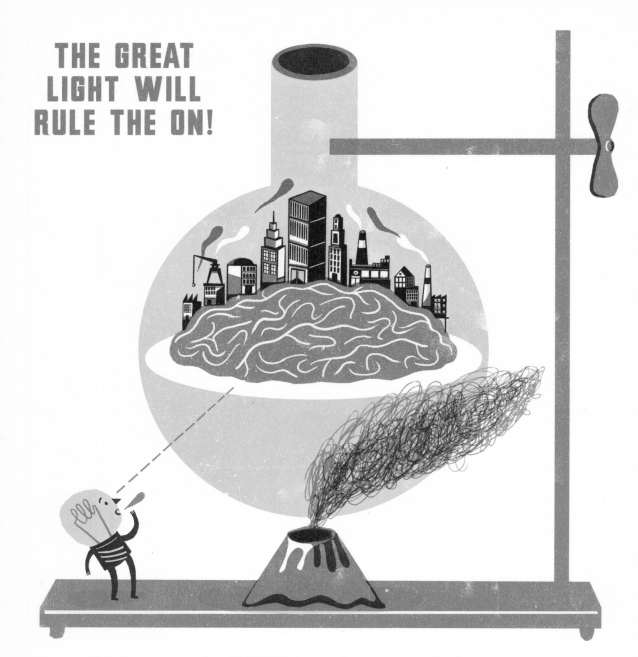

waters which were in the SPHERE from the waters which were outside the SPHERE. And it was so. 8 And MAN called the SPHERE ASSAY 1. And there was evening and there was morning, a second day. 9 And MAN said, "Let the waters in the SPHERE of ASSAY 1 be gathered together into one place, and let the dry land appear." And it was so. 10 MAN called the dry land CITY, and the waters that were gathered together he called FLUIDS. And MAN saw that it was good. 11 And MAN said, "Let the CITY put forth vegetation, plants yielding

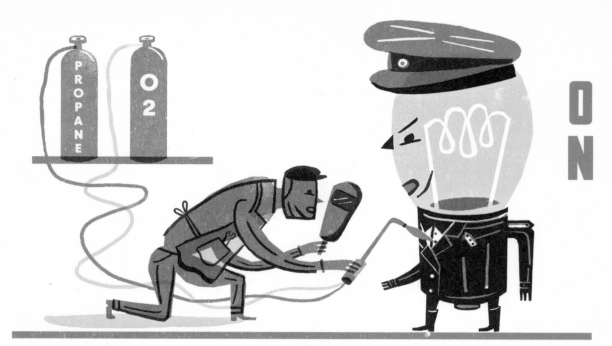

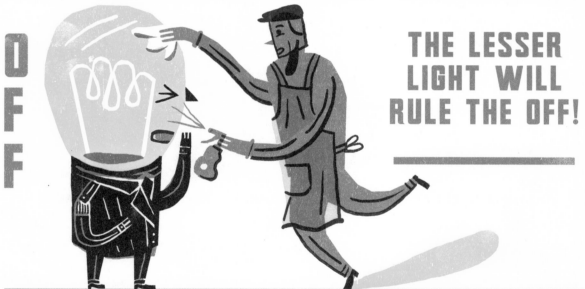

seed, and fruit trees bearing fruit in which is their seed, each according to its kind, upon the CITY. And it was so. 12 And MAN saw that it was good. 13 And there was evening and there was morning, a third day. 14 And MAN said, "Let there be lights on the SPHERE of ASSAY 1 to separate the ON from the OFF; 15 and to give light upon the CITY." And it was so. 16 And MAN made the two great lights, the greater light to rule the ON, and the lesser light to rule the OFF; 17 and MAN set them on the SPHERE of ASSAY 1 to give light upon the CITY,

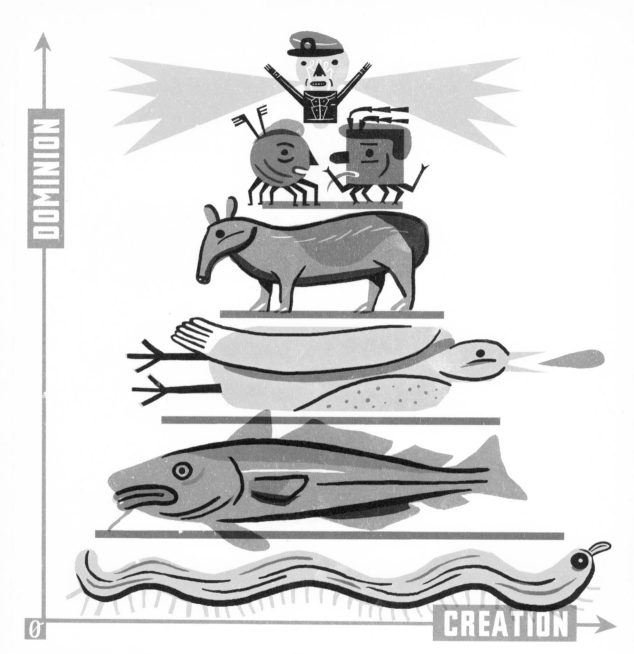

DOMINION

0

CREATION

18 and to rule over the ON and over the OFF, and MAN saw that it was good.
19 And there was evening and there was morning, a fourth DAY. **20** And MAN
said, "Let the FLUIDS bring forth swarms of living creatures, and let birds fly
above the CITY across the SPHERE of ASSAY 1." And MAN saw that it was good.
21 So MAN created the great sea monsters and every living creature that moves,
with which the FLUIDS swarm, according to their kinds, and every winged bird
according to its kind. And MAN saw that it was good. **22** And MAN blessed them,

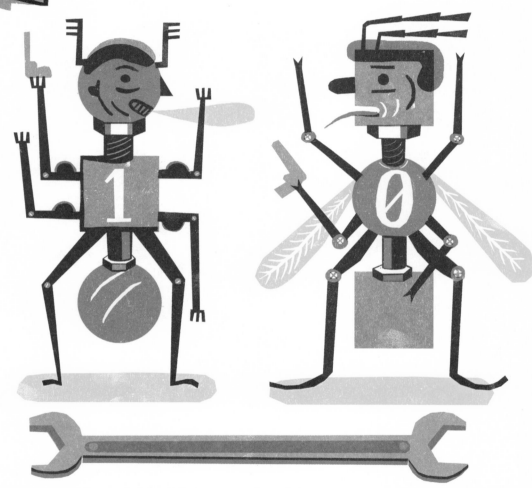

saying, "Be fruitful and multiply and fill the FLUIDS in the seas, and let birds multiply in the CITY." 23 And there was evening and there was morning, a fifth day. 24 And MAN said, "Let the CITY bring forth living creatures according to their kinds: cattle and creeping things and beasts of the CITY according to their kinds." And it was so. 25 And God saw that it was good. 26 Then MAN said, "Let us make DROIDS in our image, after our LIKENESS; and let them have dominion over the fish of the FLUIDS, and over the birds of the AIR, and over the cattle,

AND IT WAS SO.

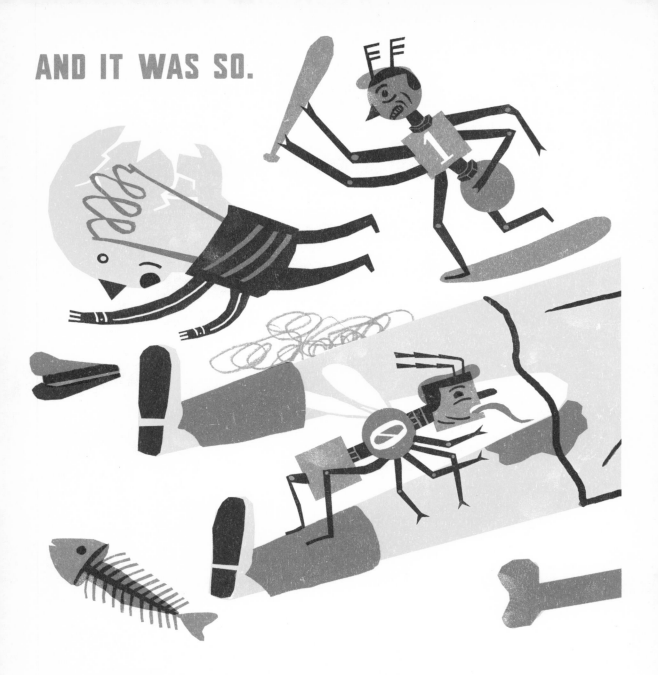

and over all the CITY, and over every creeping THING that creeps upon IT." **27** So MAN created DROIDS in his own image, ONE and ZERO he created. **28** And MAN blessed them, and MAN said to them, "Be fruitful and MULTIPLY, and fill the CITY and subdue it; and have dominion over the fish of the FLUIDS and over the birds of the AIR and over every living THING that moves upon the CITY." **29** And MAN said, "Behold, I have given you every plant yielding seed which is upon the face of all the CITY, and every tree with seed in its fruit;

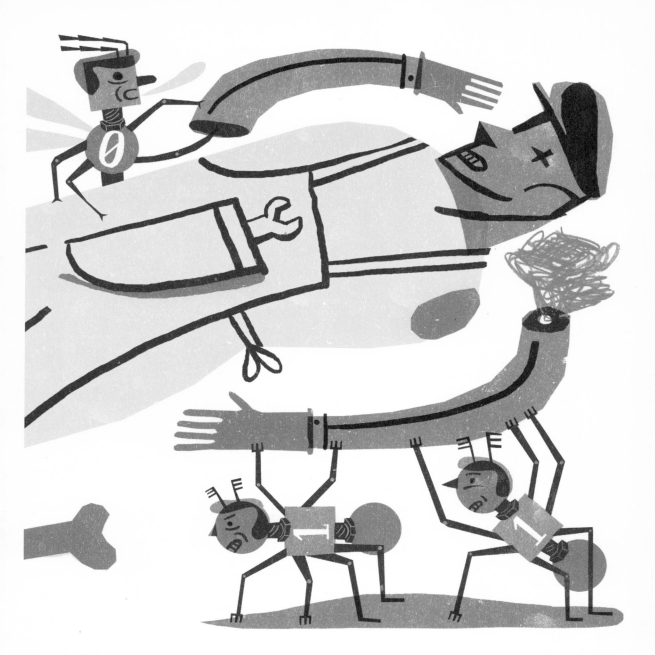

you shall have them for FOOD. 30 And to every beast of the CITY, and to every bird of the AIR, and to everything that creeps in the CITY, everything that has the BREATH of LIFE, I have given every green plant for FOOD." And it was so. 31 And MAN saw everything that he had made, and behold, it was very GOOD. And there was evening and there was morning, a sixth day. 2.1 Thus the SPHERE of ASSAY 1 was finished, and all the HOST of IT. 2.2 And on the seventh day MAN rested from all his WORK he had done in CREATION.

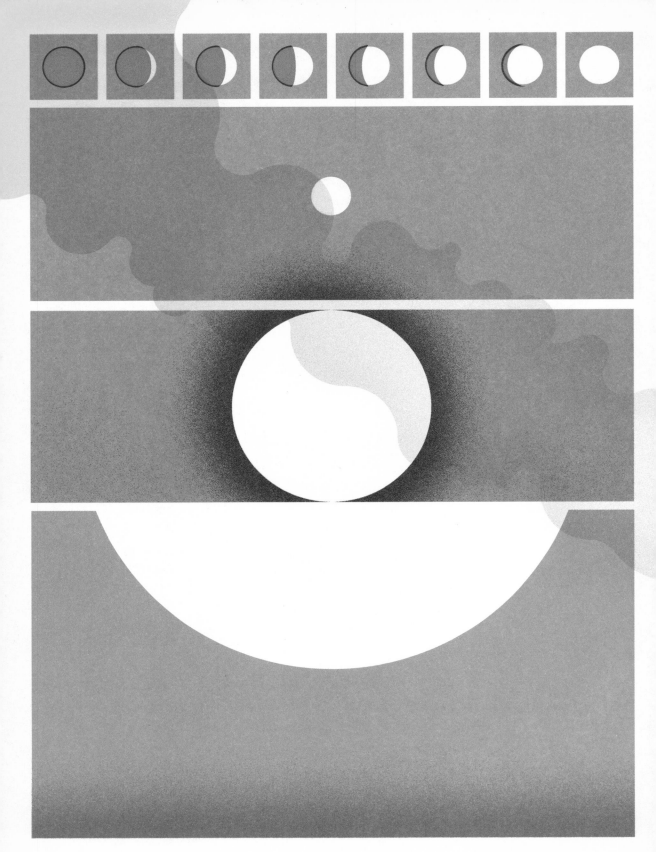

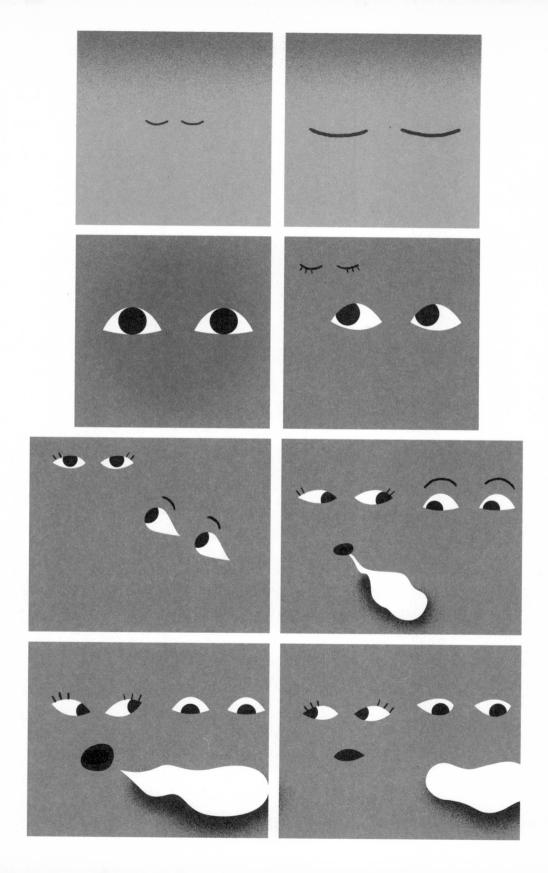

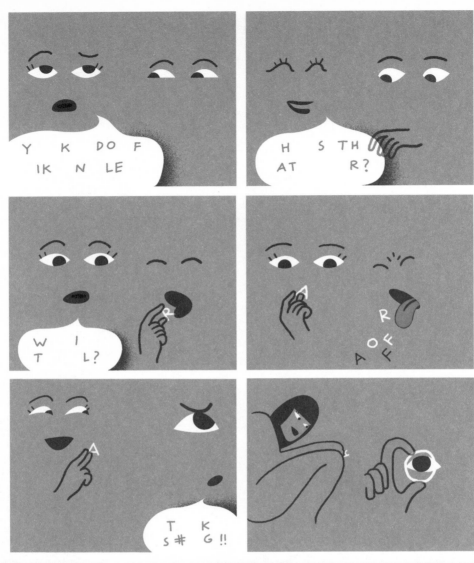
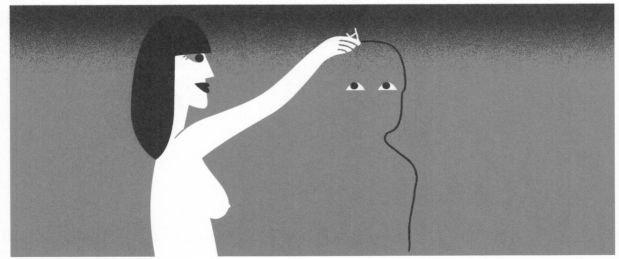

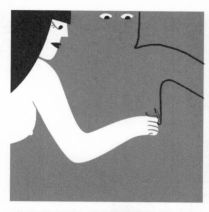
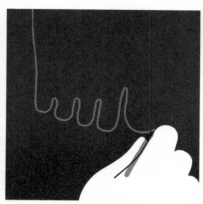
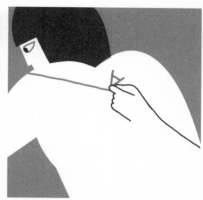

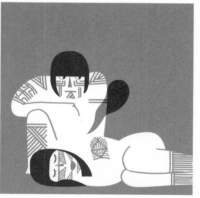
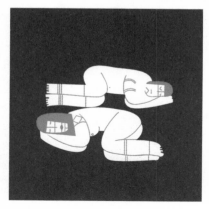

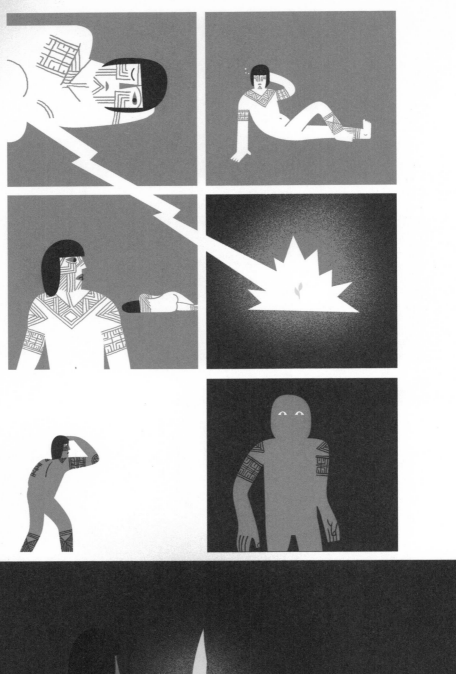
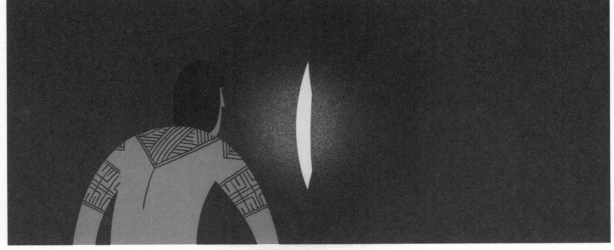

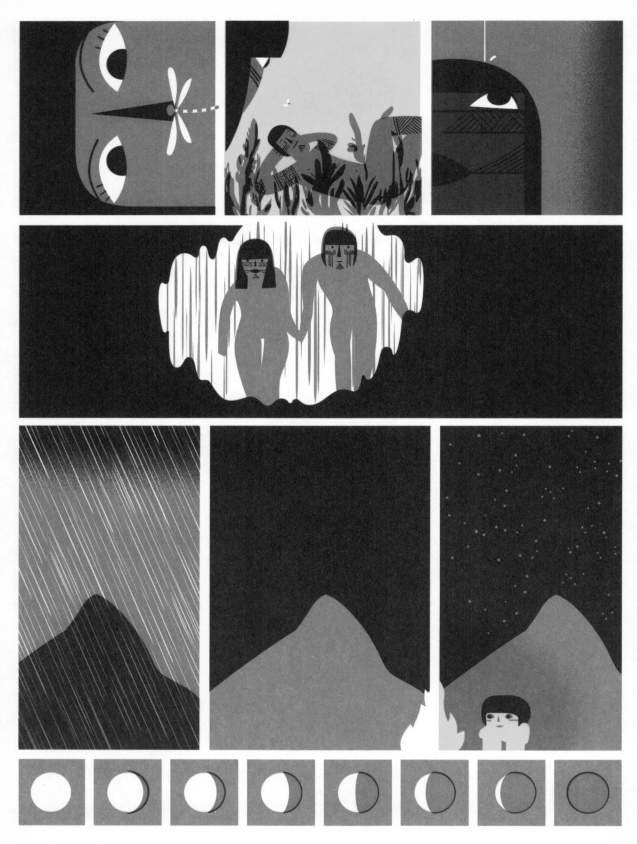

NOW, OF COURSE, I WASN'T THERE...

... SO I CAN'T BE SURE...

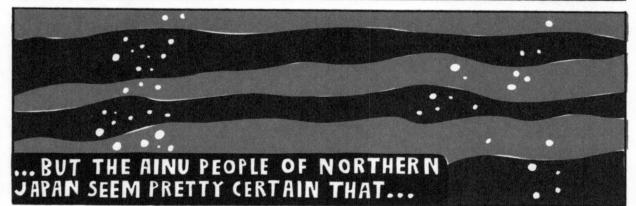

... BUT THE AINU PEOPLE OF NORTHERN JAPAN SEEM PRETTY CERTAIN THAT...

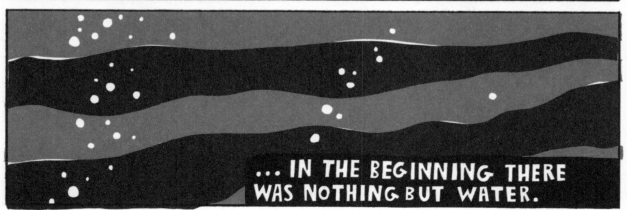

... IN THE BEGINNING THERE WAS NOTHING BUT WATER.

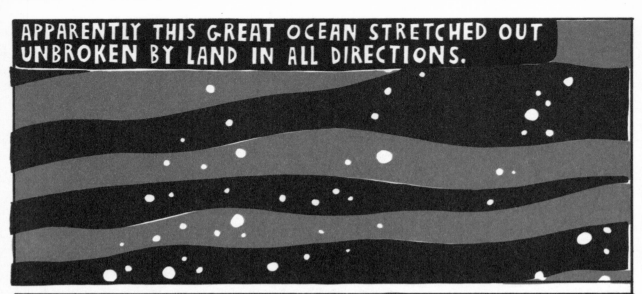

APPARENTLY THIS GREAT OCEAN STRETCHED OUT UNBROKEN BY LAND IN ALL DIRECTIONS.

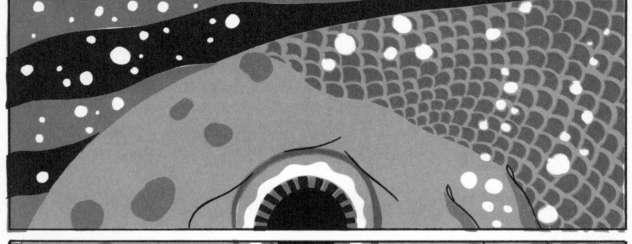

AND IF YOU CAN BELIEVE IT, IT WAS TOTALLY EMPTY...

...BUT FOR A HUGE TROUT NAMED MOSHIRI IKKEWE CHEP ON WHOSE BACK IT ALL RESTED.

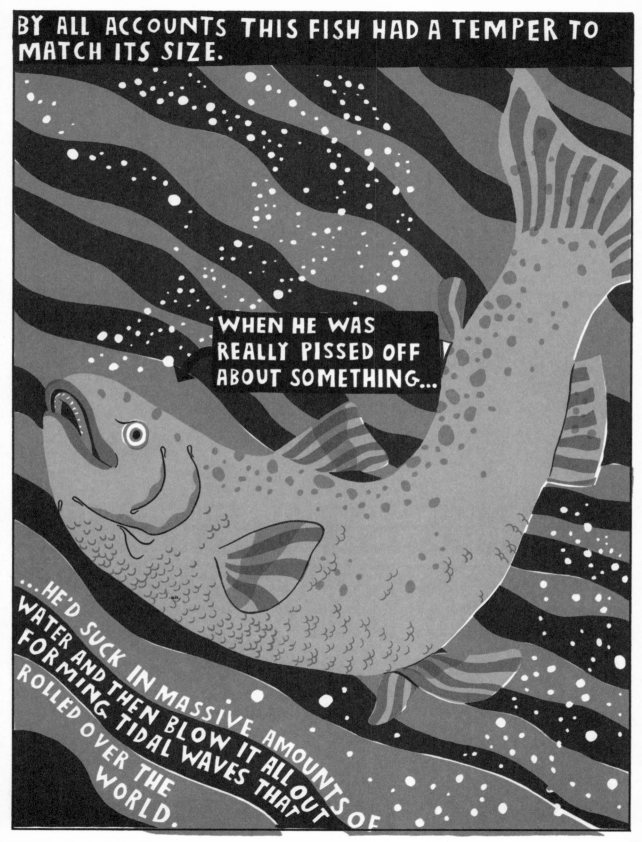

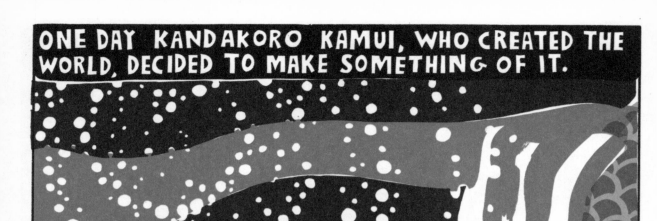

ONE DAY KANDAKORO KAMUI, WHO CREATED THE WORLD, DECIDED TO MAKE SOMETHING OF IT.

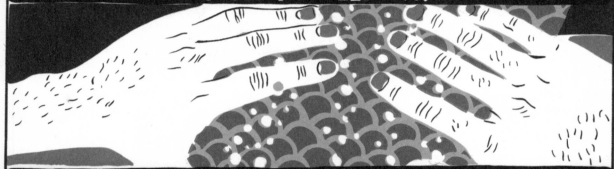

HOWEVER HE WAS AFRAID MOSHIRI IKKEWE CHEP'S TEMPER MIGHT CAUSE PROBLEMS...

...SO HE POSITIONED TWO DEITIES, ONE ON EITHER SIDE OF THE FISH TO HOLD HIM DOWN & KEEP HIM CALM.

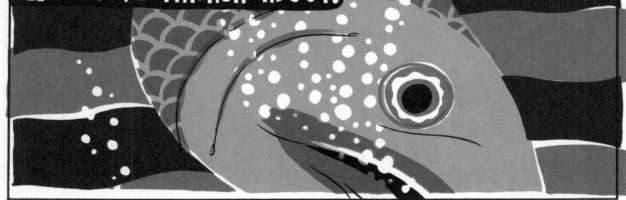

THE AINU RECKON THAT EARTHQUAKES OCCUR WHEN THESE GODS NEGLECT THEIR DUTY & THE TROUT IS ALLOWED TO THRASH ABOUT.

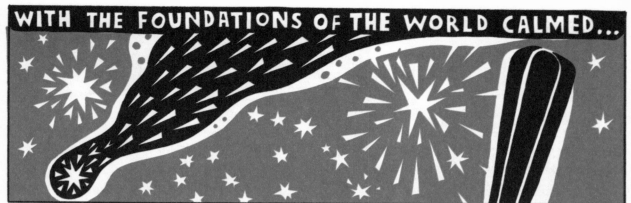

WITH THE FOUNDATIONS OF THE WORLD CALMED...

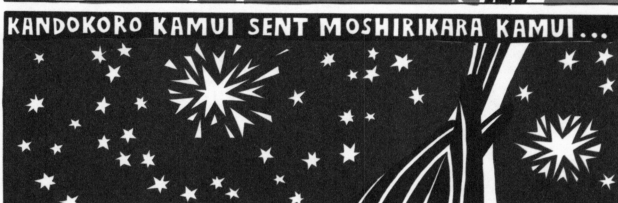

KANDOKORO KAMUI SENT MOSHIRIKARA KAMUI...

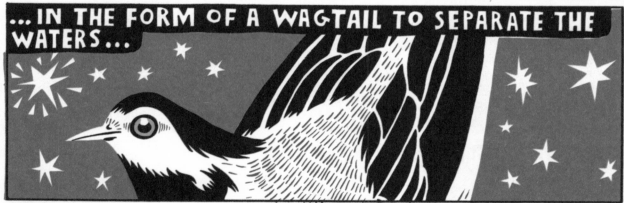

...IN THE FORM OF A WAGTAIL TO SEPARATE THE WATERS...

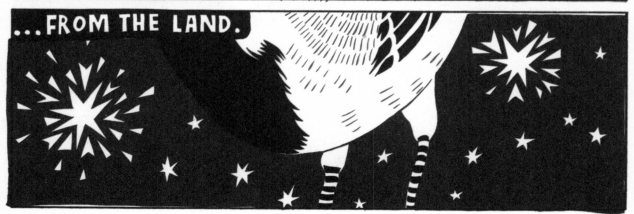

...FROM THE LAND.

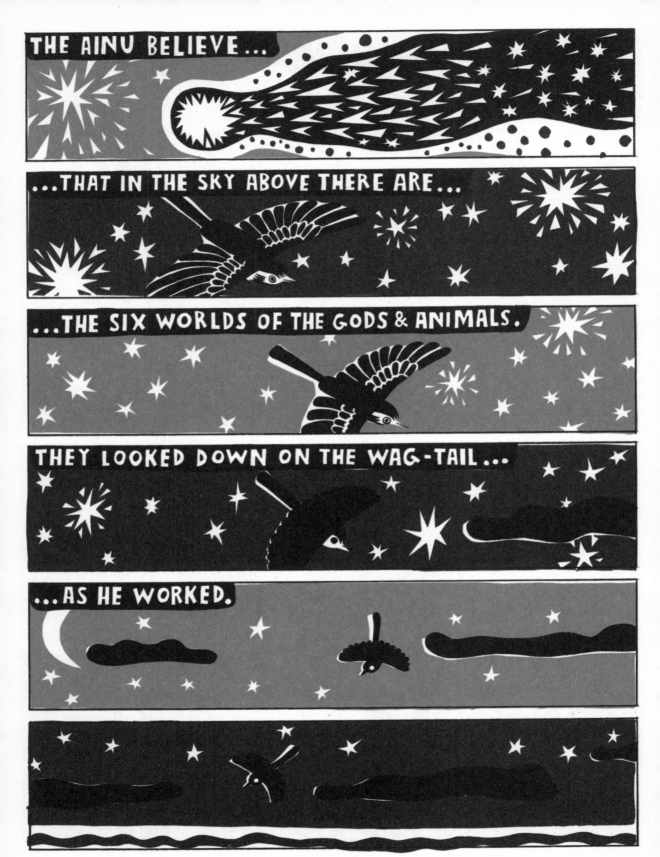

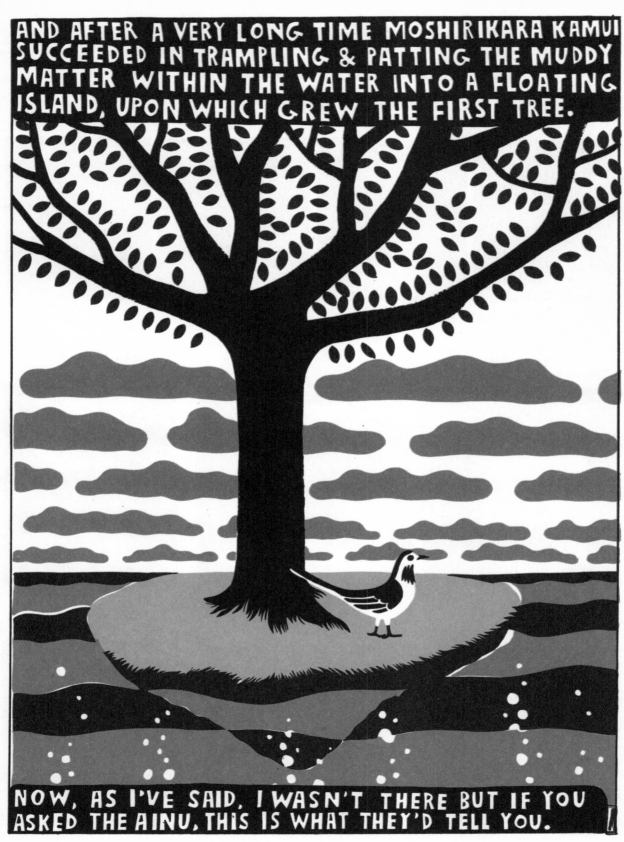

AND AFTER A VERY LONG TIME MOSHIRIKARA KAMUI SUCCEEDED IN TRAMPLING & PATTING THE MUDDY MATTER WITHIN THE WATER INTO A FLOATING ISLAND, UPON WHICH GREW THE FIRST TREE.

NOW, AS I'VE SAID, I WASN'T THERE BUT IF YOU ASKED THE AINU, THIS IS WHAT THEY'D TELL YOU.

MASTERS of THE UNIVERSE

IN THE BEGINNING THERE WAS NOTHING. ONLY TIME. BUT SINCE THERE WAS NO ONE TO COUNT THE TIME, THERE MAY AS WELL HAVE BEEN NOTHING

AND THEN THERE WAS AN EGG...
DON'T ASK HOW IT GOT THERE, OK. EVERY STORY HAS TO HAVE A BEGINNING AND THIS ONE BEGINS WITH AN EGG, FLOATING IN AN INFINITE, EMPTY COSMOS.

AND FROM THIS EGG CAME
≡ BIRDMAN ≡

HE WAS THE TOP CAT, KING GOD, GODFATHER, COSMIC ARCHITECT.

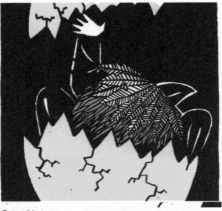

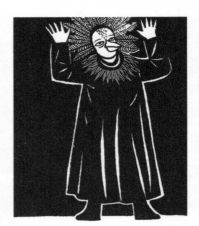

HE IMAGINED A TREE
AND A TREE WAS THERE.

BIRDMAN SAT IN HIS TREE FOR MANY MILLIONS OF MILLENNIA. ENTERTAINED ALWAYS BY THE BOUNDLESS POSSIBILITIES OF HIS INFINITELY POWERFUL IMAGINATION...

THEN HE LAID TWO EGGS. NO, SERIOUSLY HE DID! DON'T ASK HOW, JUST BELIEVE IT, ALRIGHT!

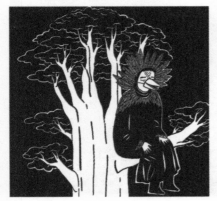

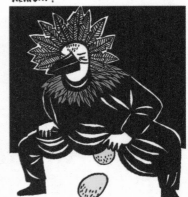

FROM ONE EGG CAME HIS DAUGTER, KIDDO.

AND FROM ONE EGG CAME HIS SON, KID.

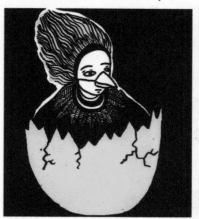

AND THEY ALL SAT IN THE TREE, AND CONTEMPLATED THE MYSTERIES OF SPACE AND TIME, AND OTHER DEEP STUFF TOO. THEN SOMETHING OCCURRED TO KID...

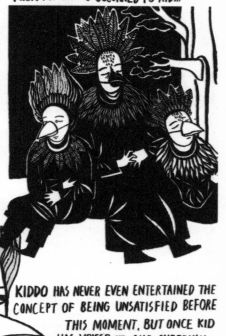

Say, Kiddo. Do you ever feel like we should do something other than sit in this tree thinking about the profound emptiness of the cosmos?

Wow. That's a novel thought.

KIDDO HAS NEVER EVEN ENTERTAINED THE CONCEPT OF BEING UNSATISFIED BEFORE THIS MOMENT, BUT ONCE KID HAS VOICED IT SHE SUDDENLY REALISES THAT SHE COULD QUITE FANCY A CHANGE:

SO THEY GO TO BIRDMAN, THEIR FATHER.

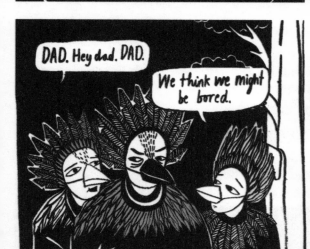

DAD. Hey dad. DAD.

We think we might be bored.

BIRDMAN IS NOT BEST PLEASED TO BE DISTURBED. HE HAS BEEN DWELLING DEEPLY ON AN IDEA FOR SEVERAL THOUSAND YEARS, AND HAS QUITE A WAY TO GO BEFORE HE'S READY TO TALK.

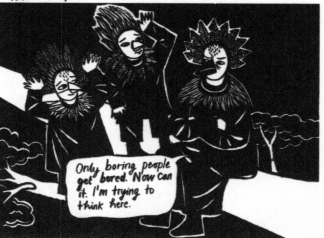

Only boring people get bored. Now can it. I'm trying to think here.

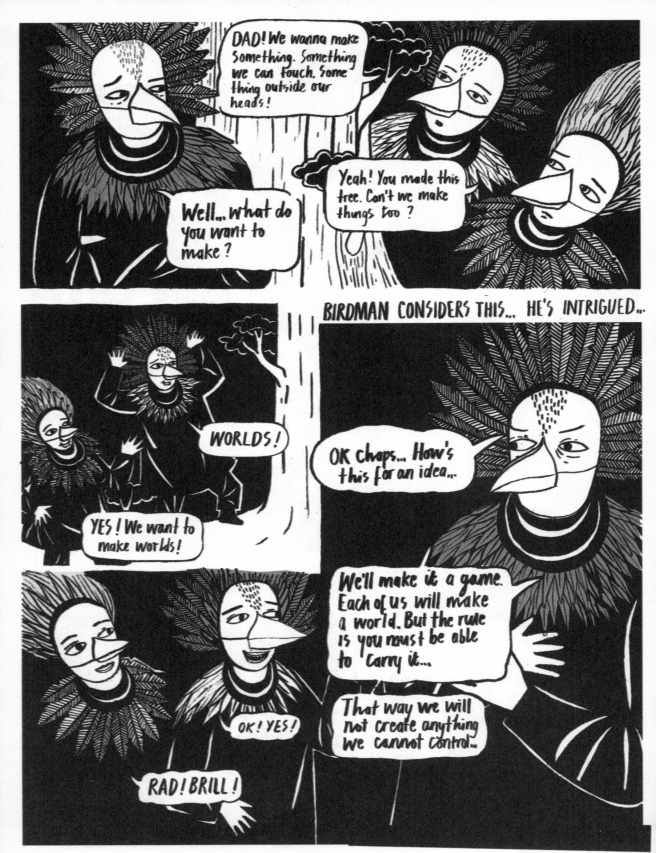

SO IT COMES THE TIME TO COMPARE WHAT THEY HAVE MADE. KID GOES FIRST. HE HAS A BASIN THAT HE HOLDS IN HIS HANDS. IN THE BASIN IS AN ANGEL HOLDING A TINY WORLD. THE ANGEL IS STANDING IN A BOWL OF RUBIES, BALANCED ON THE BACK OF A COW, PERCHED ON A FISH, SWIMMING IN ENDLESS CIRCLES AROUND THE BLUE WATER.

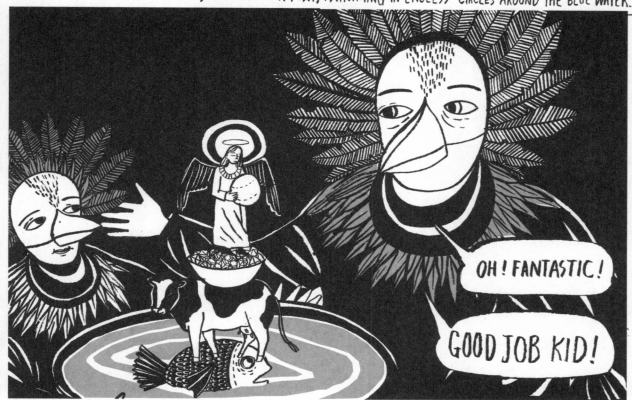

OH! FANTASTIC!

GOOD JOB KID!

NEXT BIRDMAN SHOWS HIS WORLD. WELL HE DOESN'T EXACTLY, BECAUSE HE HAS MADE IT IN HIS MIND'S EYE. HE INVITES THEM TO LOOK INTO THE DEPTHS OF HIS INKY BLACK PUPIL. KID AND KIDDO ARE NOT IMPRESSED

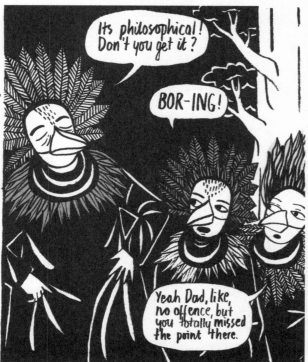

Its philosophical! Don't you get it?

BOR-ING!

Yeah Dad, like, no offence, but you totally missed the point there.

THEY CAN'T SEE ANYTHING.

I CALL THEM HUMANS!

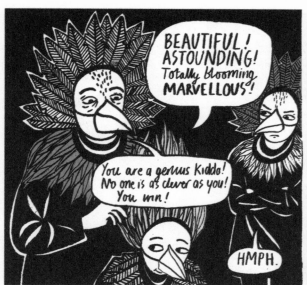

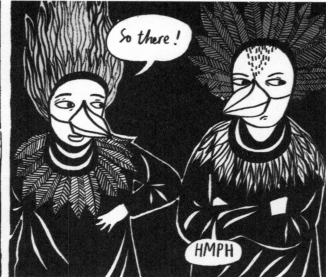

KID IS PISSED OFF. HE'S MONUMENTALLY JEALOUS BEFORE HE REALISES WHAT HE'S DOING HE'S CREEPING UP TO THE SLEEPING KIDDO, BRANDISHING A PAIR OF SCISSORS!

THE HAIR FALLS FROM HER HEAD AND THE WORLD IN IT GOES TUMBLING AWAY, INTO THE INFINITE COSMOS. AS IT TUMBLES IT BEGINS TO GROW AND EXPAND...

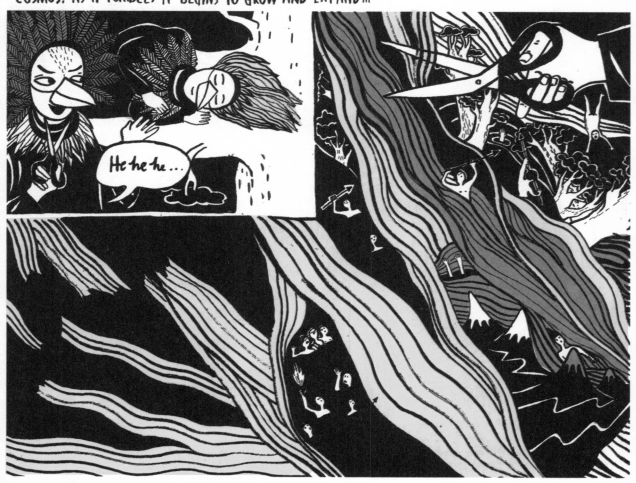

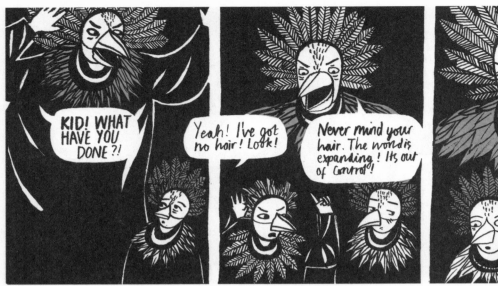

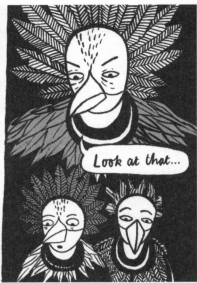

KIDDO'S WORLD, SO **PERFECT** IN **MINIATURE**, IS GROWING BEFORE THEIR EYES. THEY WATCH IN HORROR AS THE LITTLE PEOPLE AND THE MOUNTAINS AND RIVERS AND TREES BEGIN TO SHAPE AND FORM... A WORLD IS BEING MADE, AND THERE IS NOTHING THEY CAN DO...

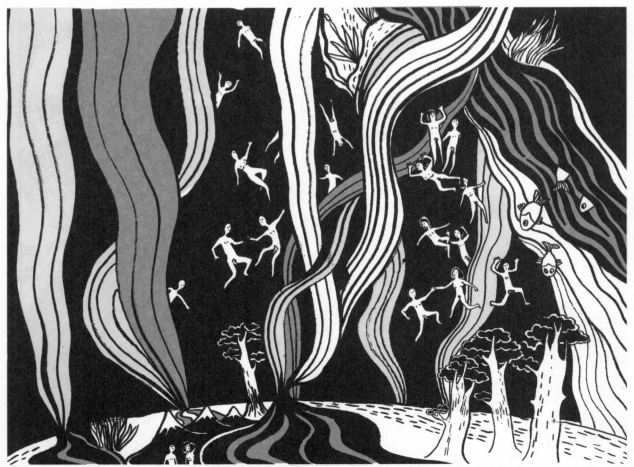

AND THAT IS THE STORY OF HOW ONE BAD HAIRCUT CAUSED OUR WORLD TO BE. AMAZING RIGHT?

The BIGGEST DANGER!

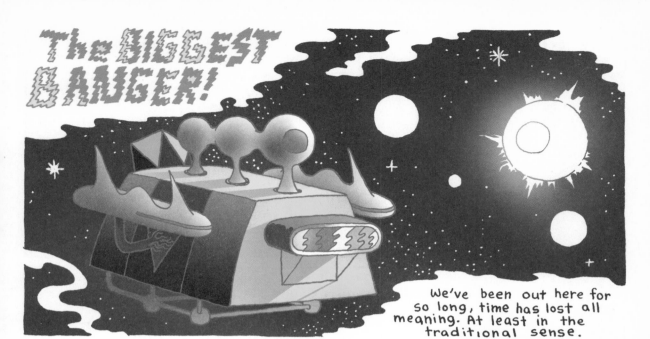

We've been out here for so long, time has lost all meaning. At least in the traditional sense.

The only time we're counting now is the time we have left on the Ecosystem Reformation Device.

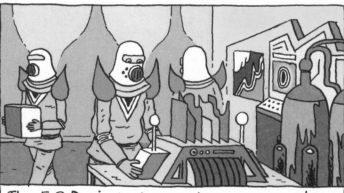

The E.R.D. is to be used on our new home, if we find one, to stabilize the planet's environment and suit it to our needs.

The younger generations have become disconnected from our mission and are obsessed with their childish forms of entertainment.

Most of our children have never stepped on ground that doesn't vibrate from the hum of engines, or have filled their lungs with real air

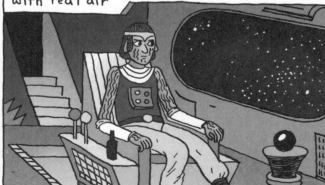

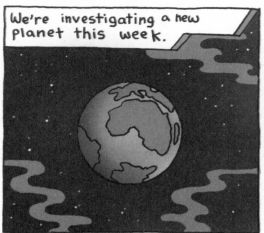

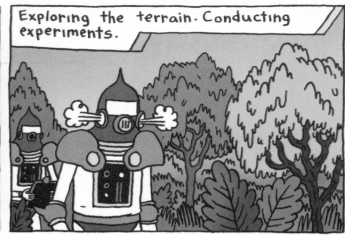

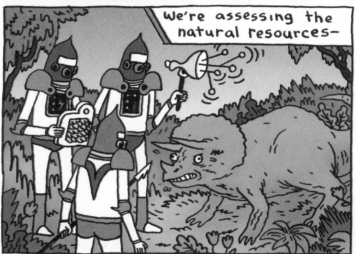

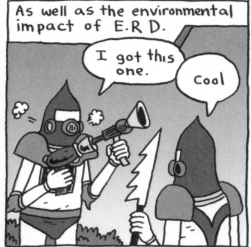

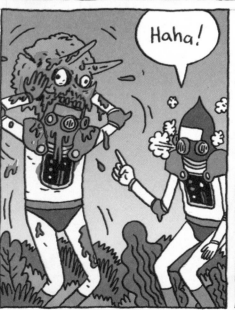

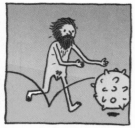
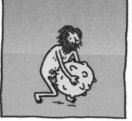
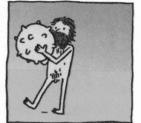
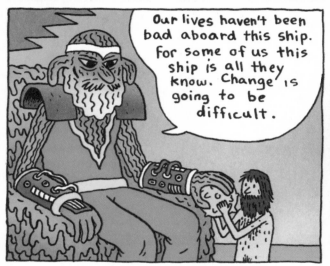
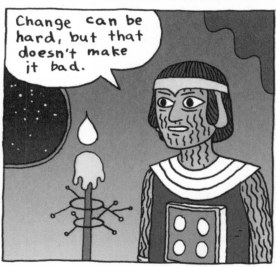
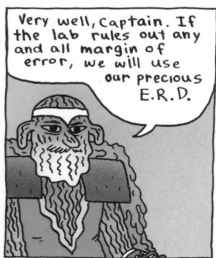
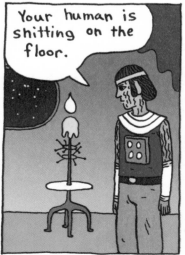
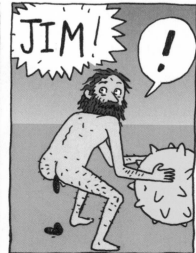

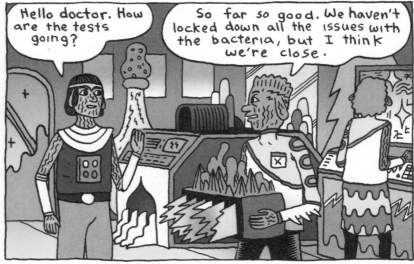

Hello doctor. How are the tests going?

So far so good. We haven't locked down all the issues with the bacteria, but I think we're close.

These are the most promising results to date. All of the bio-tech work is almost done.

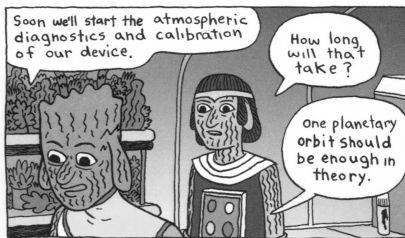

Soon we'll start the atmospheric diagnostics and calibration of our device.

How long will that take?

One planetary orbit should be enough in theory.

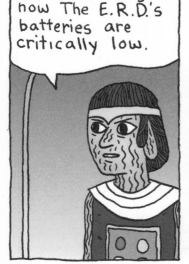

Start calibrating now The E.R.D.'s batteries are critically low.

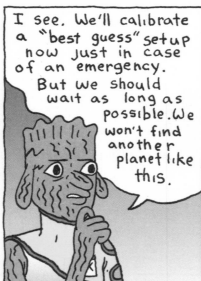

I see. We'll calibrate a "best guess" setup now just in case of an emergency. But we should wait as long as possible. We won't find another planet like this.

There will be risk in using the device prematurely, but what choice do we have?

Agreed.

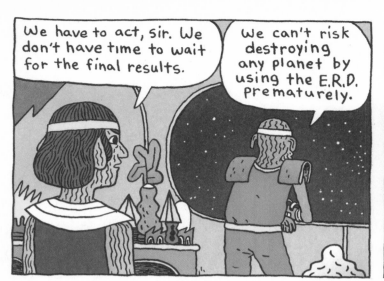

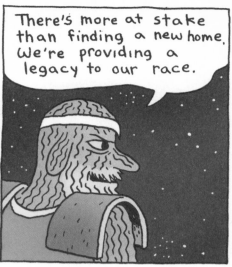

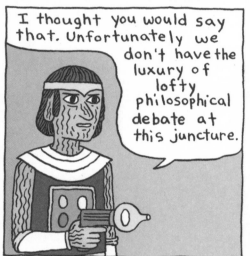

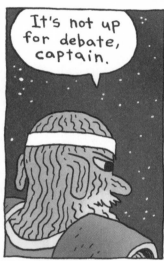

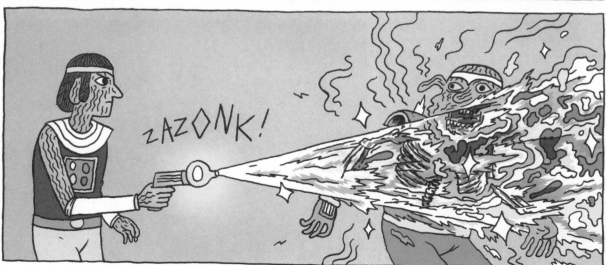

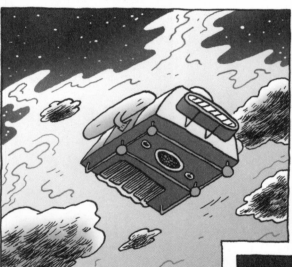

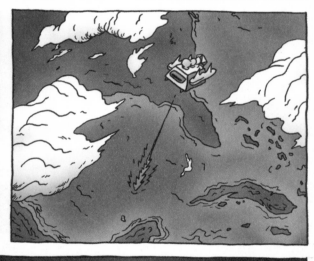

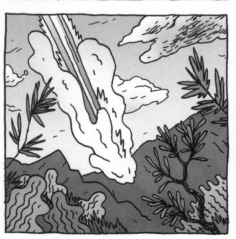

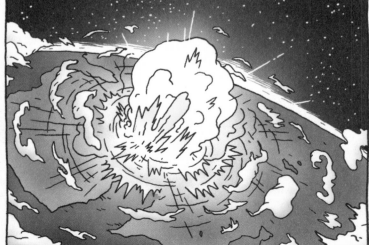

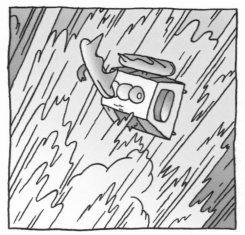

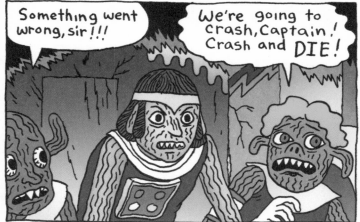

Something went wrong, sir!!!

We're going to crash, Captain! Crash and DIE!

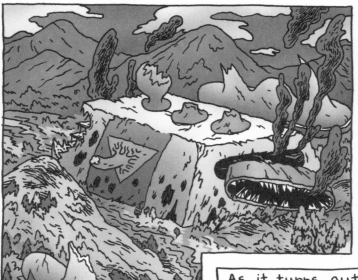

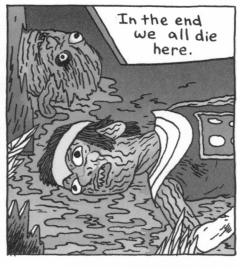

In the end we all die here.

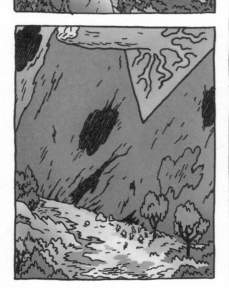

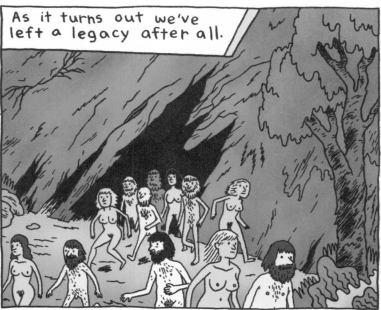

As it turns out we've left a legacy after all.

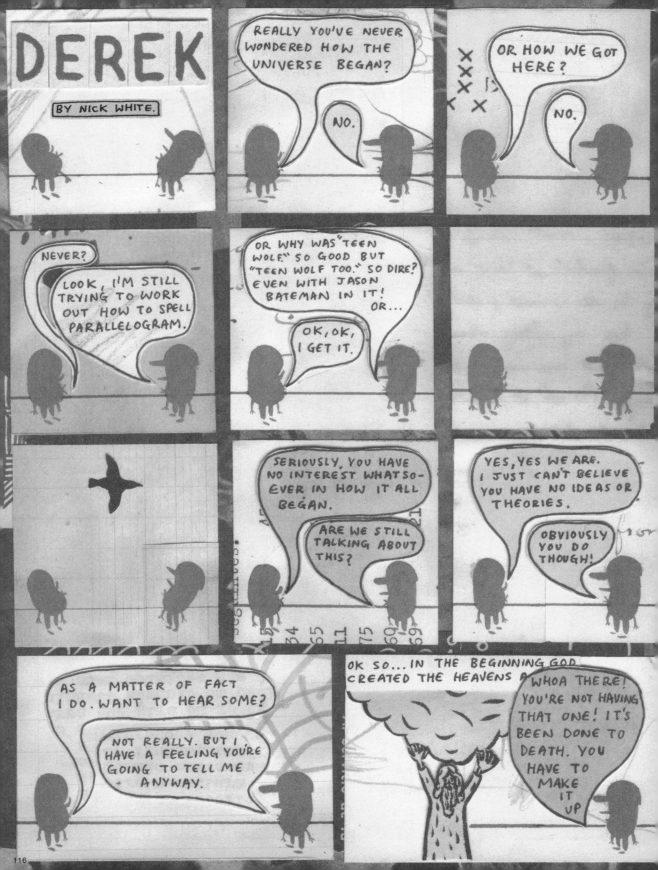

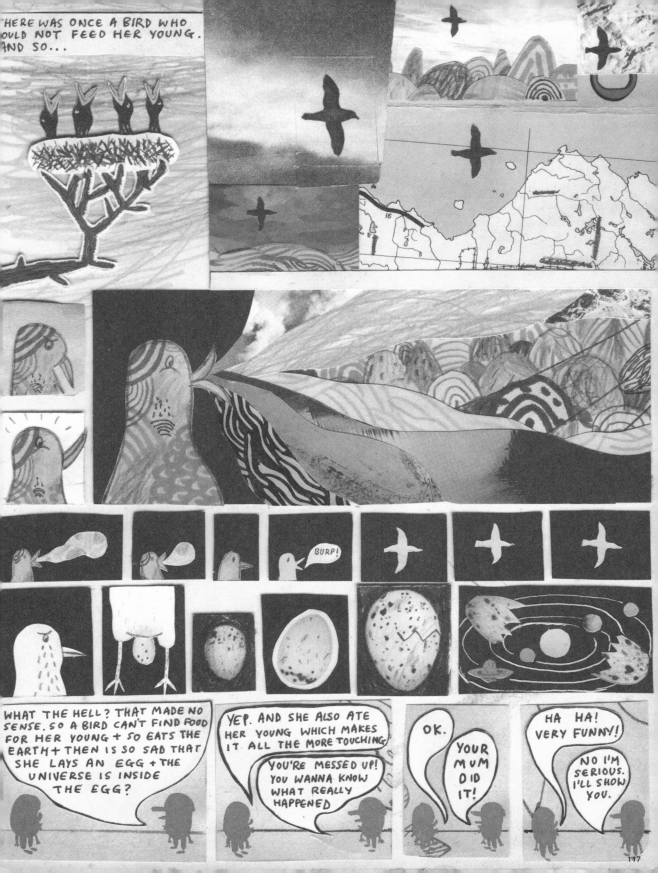

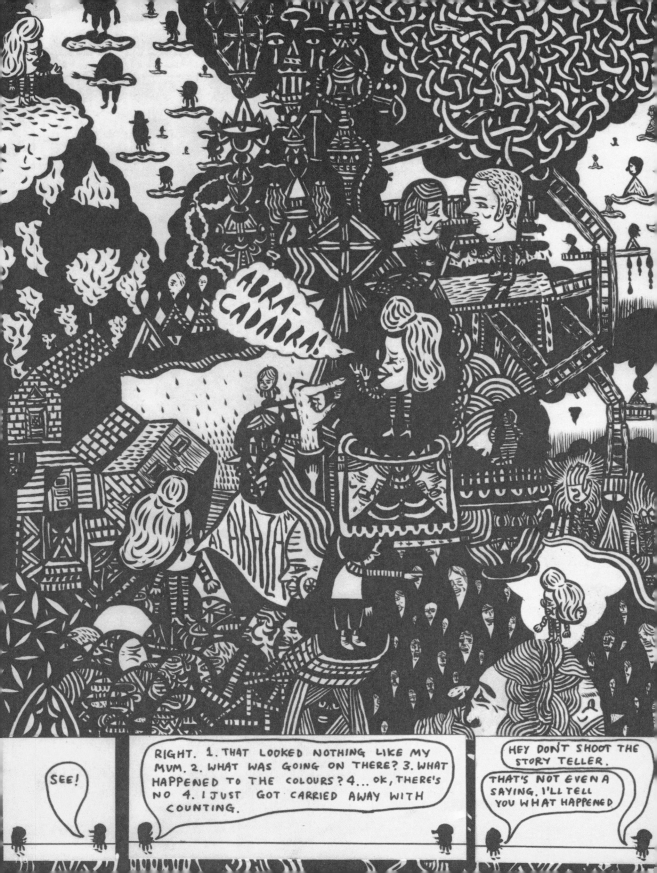

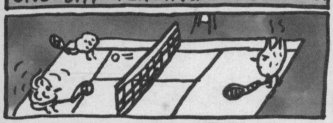
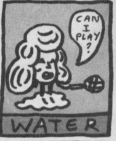
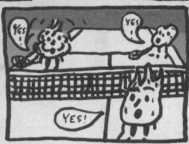

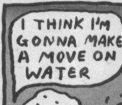
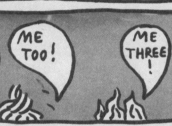
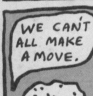
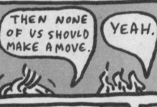

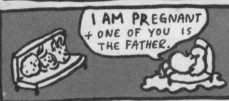

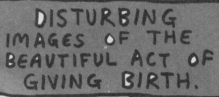
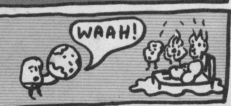
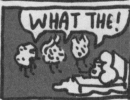
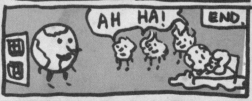
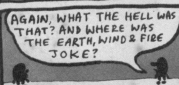
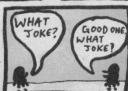

OK, THATS NOT THE END.

BUT THE UNIVERSE DID START WHEN SOMEBODY THOUGHT OF IT.

UP UNTIL THEN THERE WAS NOTHING.

WELL NEARLY NOTHING

THERE WAS A SLICE OF NOTHING.

A LARGER SECTION OF NOTHING.

AND A WHOLE LOT OF NOTHING INBETWEEN.

BUT THAT WAS IT.

OK. THAT WASN'T IT.

IN THE MIDST OF ALL THIS NOTHING FLOATING ABOUT WAS A SOMETHING.

THAT SOMETHING WAS DEREK.

DESPITE HIS NAME, THE FACT THAT HE RESEMBLED A MAN, VAGUELY, AND DESPITE H..M BEING A 'HE', DEREK WAS NOT A MAN.

HE WAS DEREK.

GOT IT?

HE WAS DEFINITELY NOT A GOD EITHER

SO DON'T START WORSHIPPING HIM OR ANYTHING.

HE'D HATE THAT.

MOST GODS DO AND HE WASN'T A GOD.

OK?

SHEESH!

DEREK TENDED TO JUST FLOAT ABOUT SAID NOTHINGNESS AND DAY DREAM.

UNFORTUNATELY DUE TO THE NATURE OF HIS SURROUNDINGS HE MOSTLY DAY DREAMED ABOUT NOTHING.

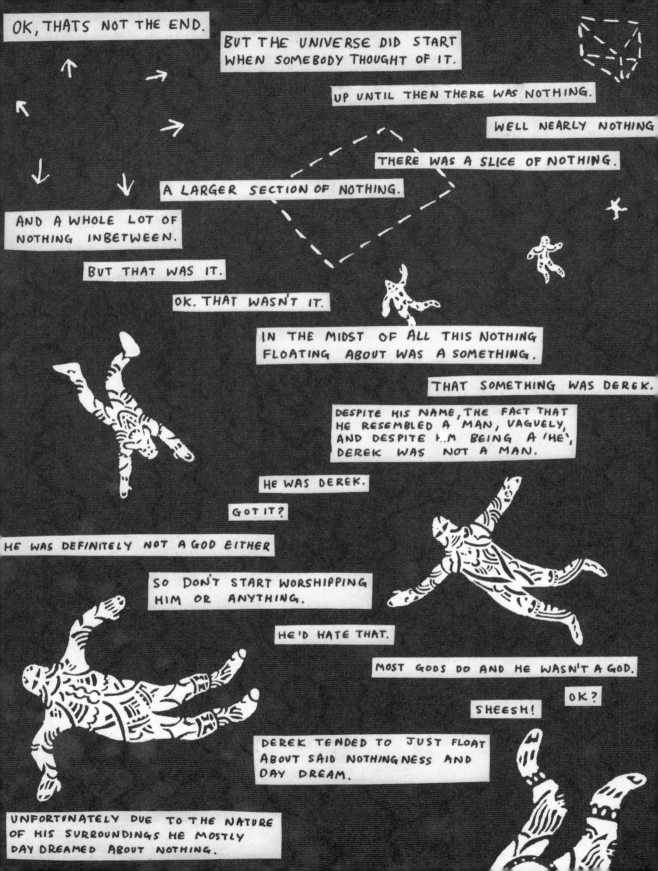

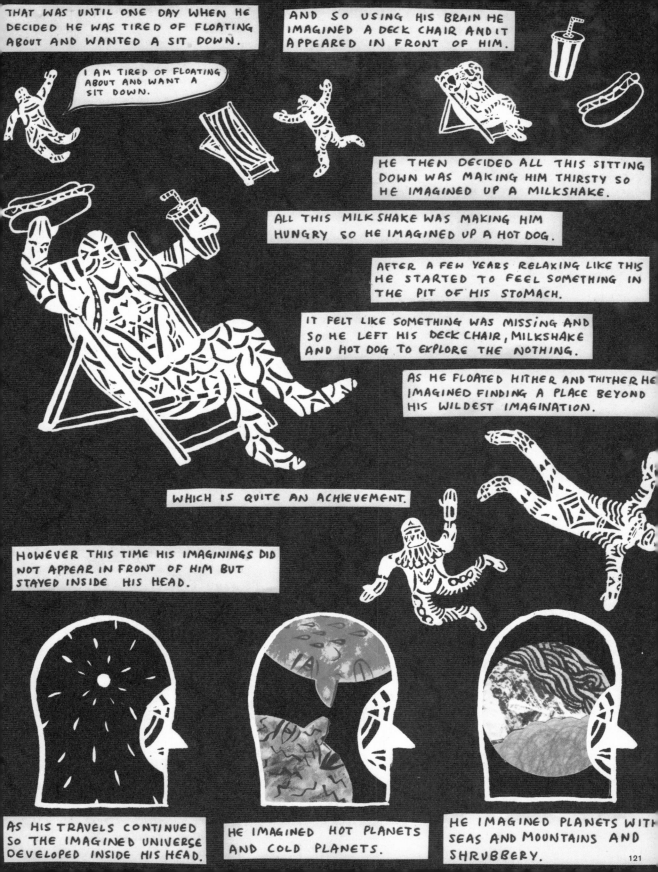

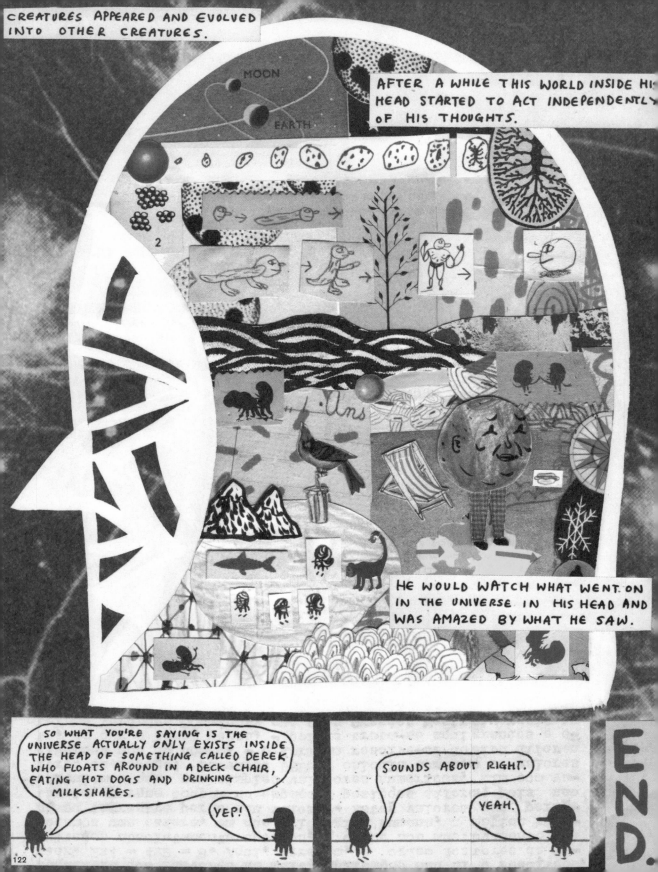

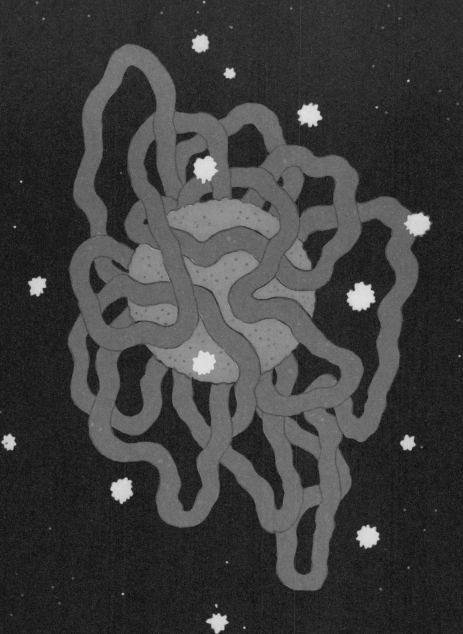

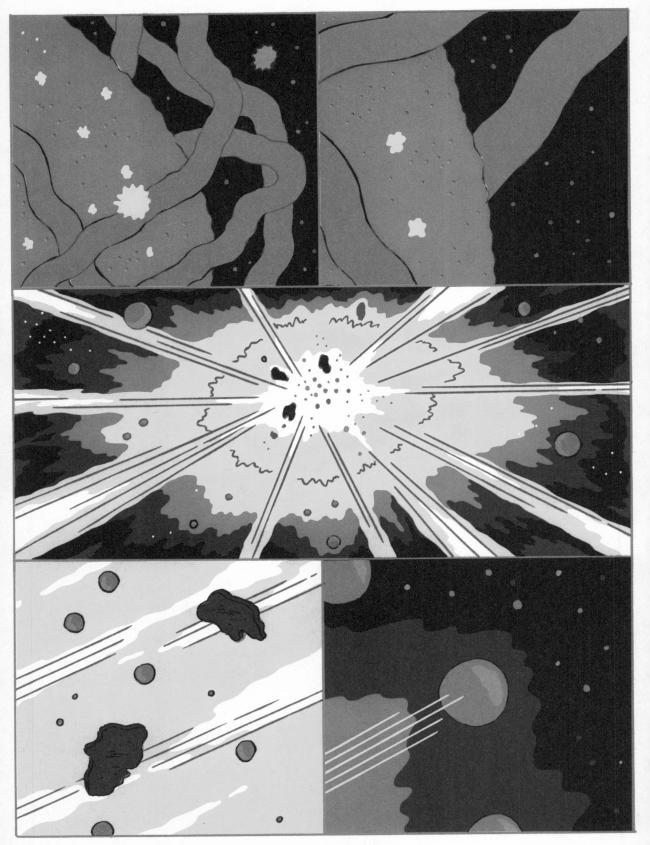

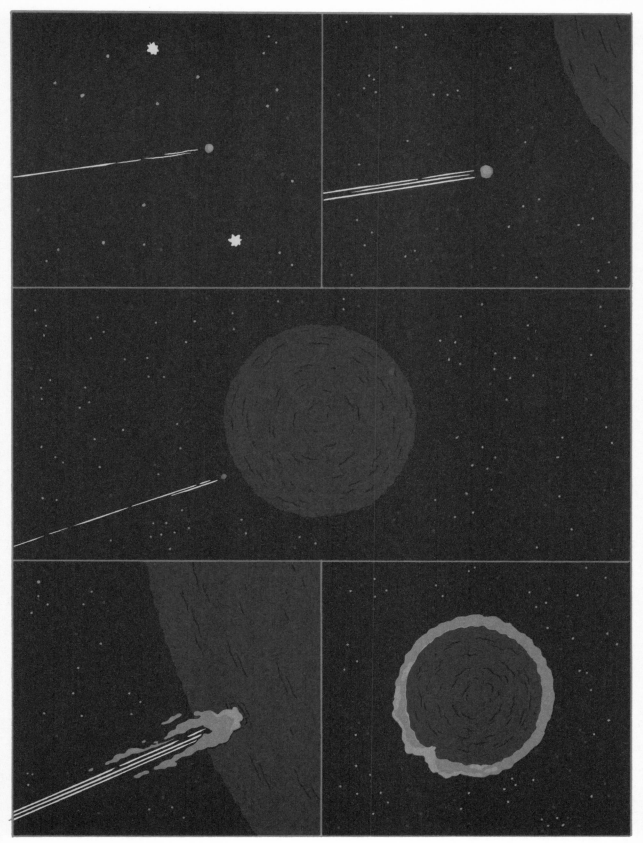

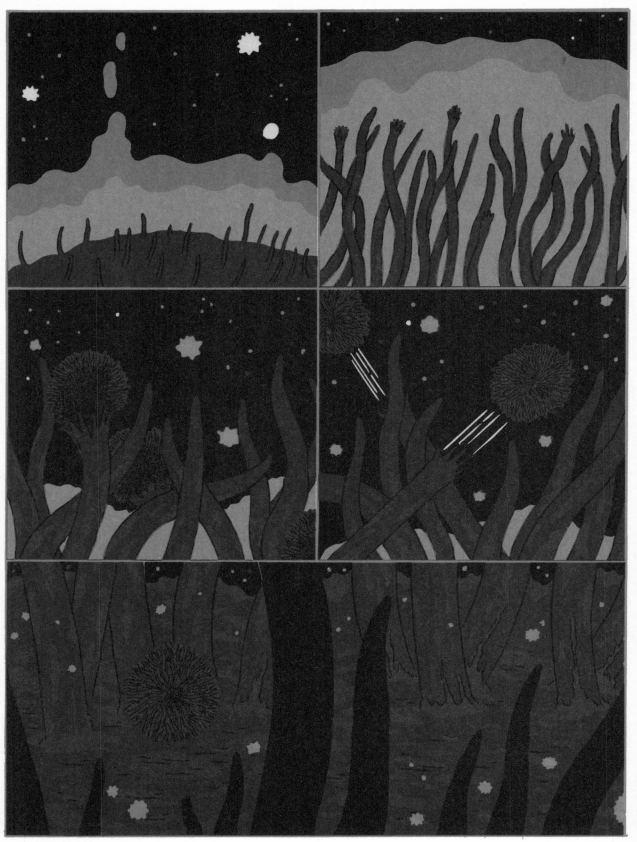

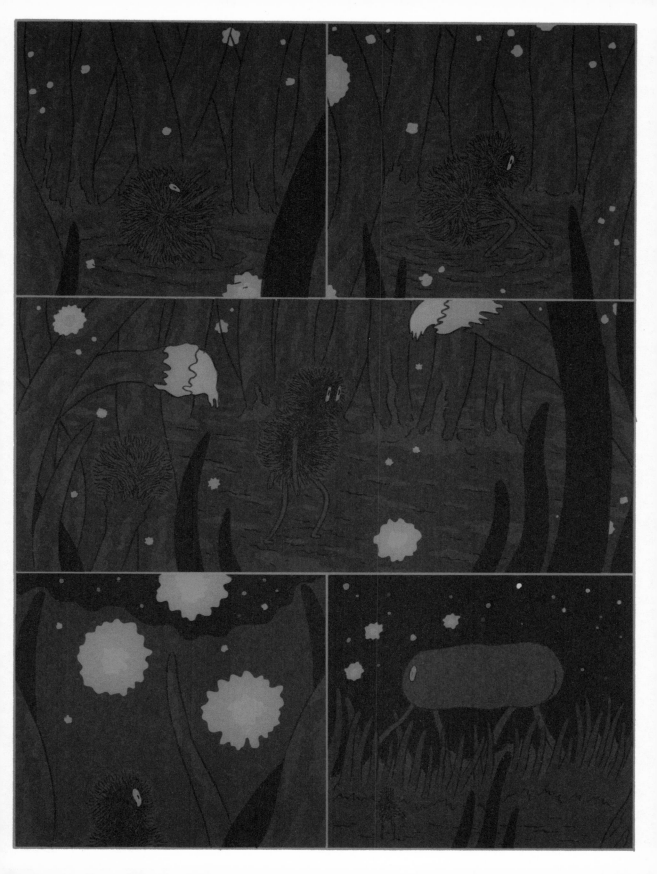

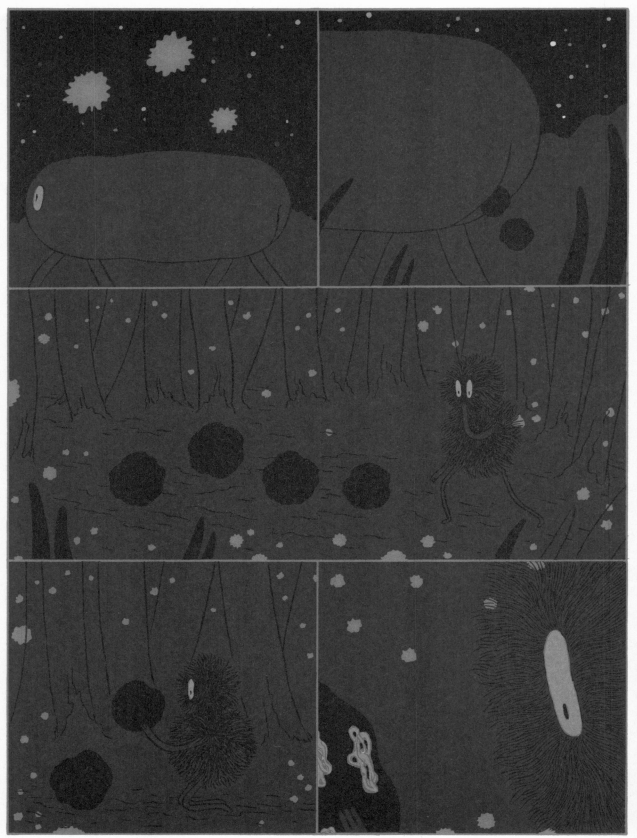

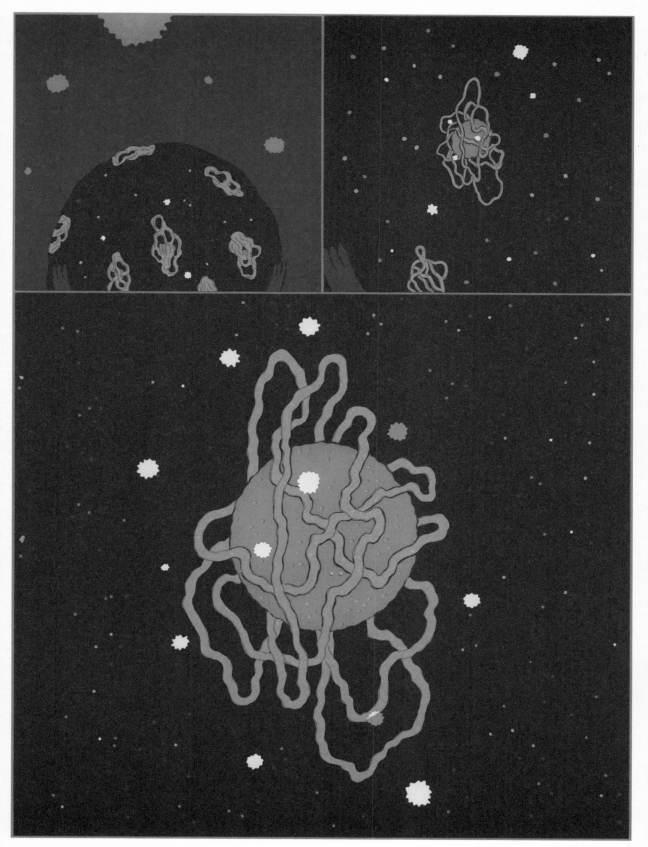

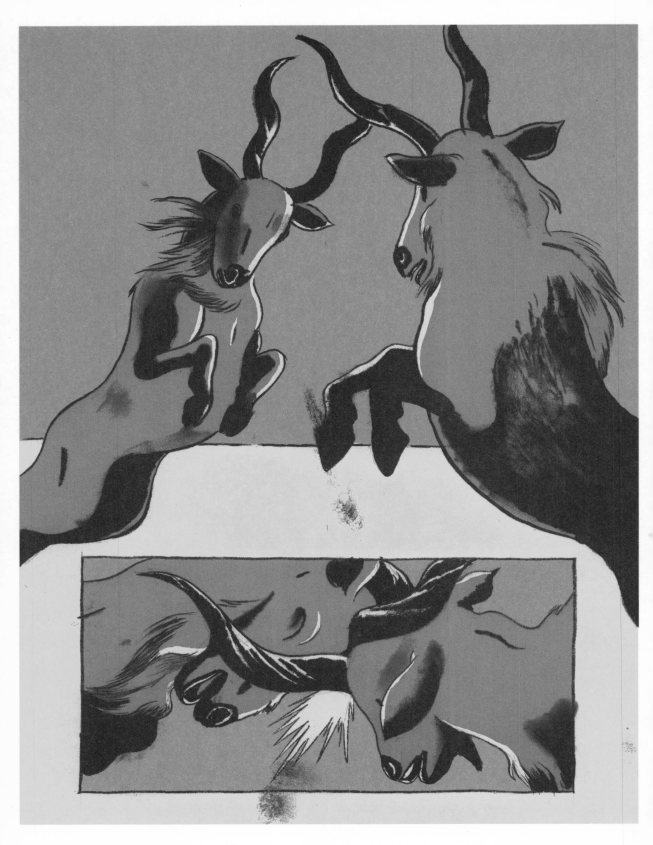

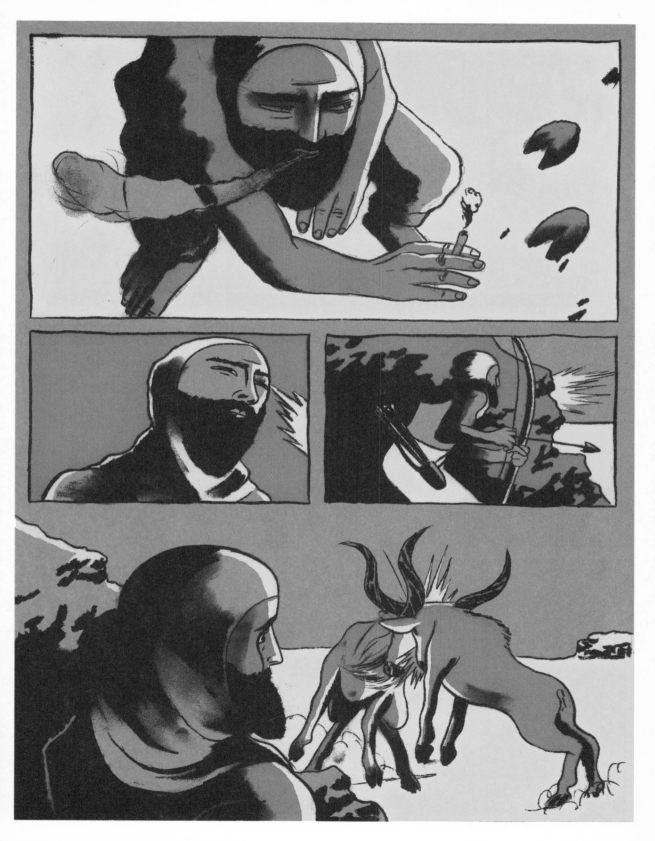

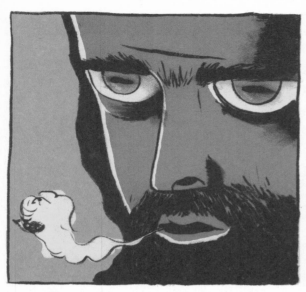

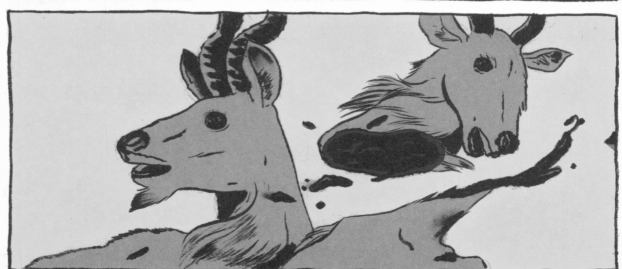

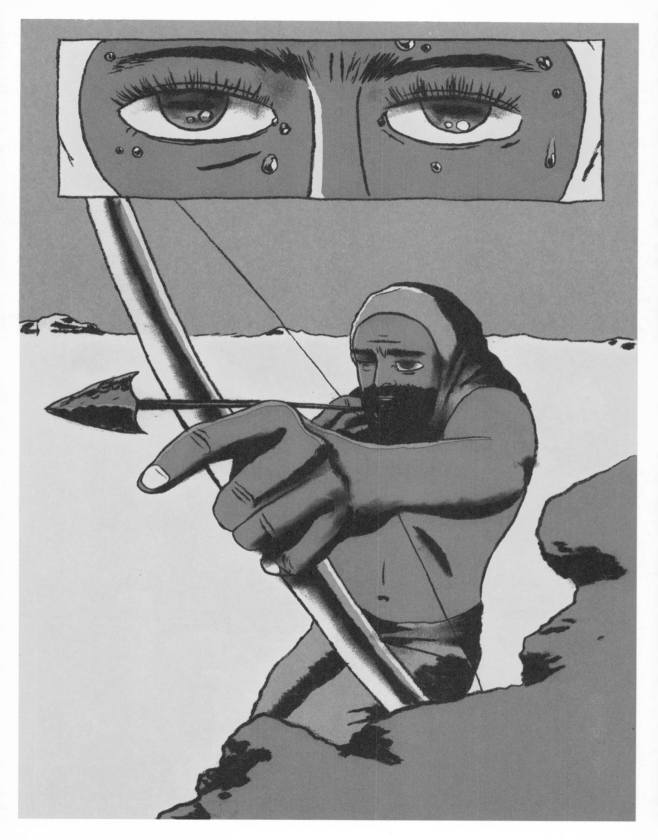

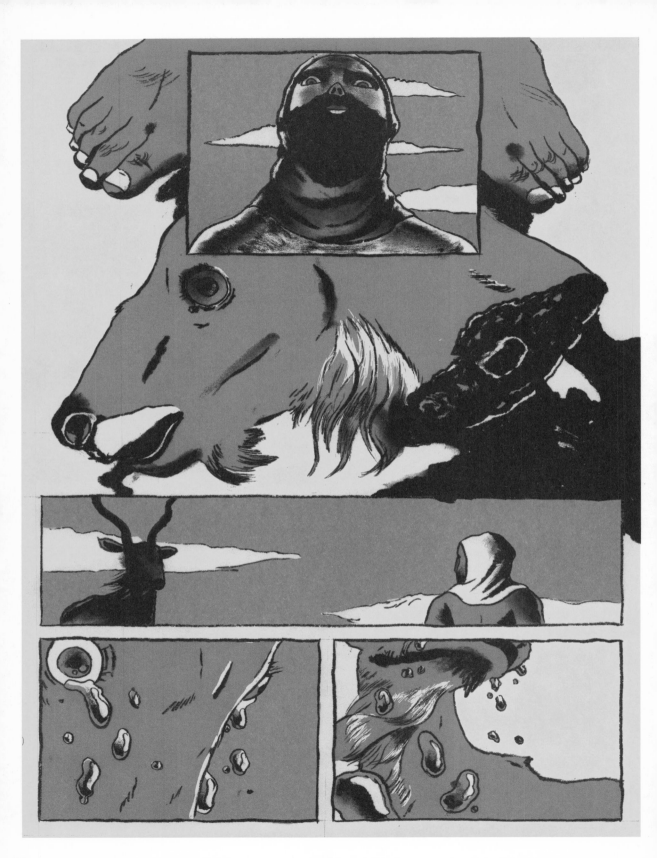

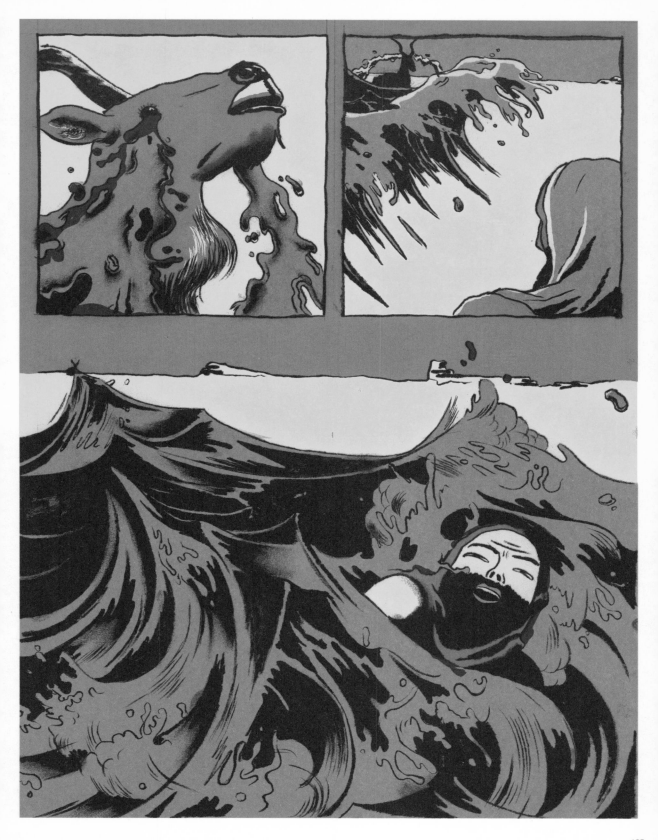

135

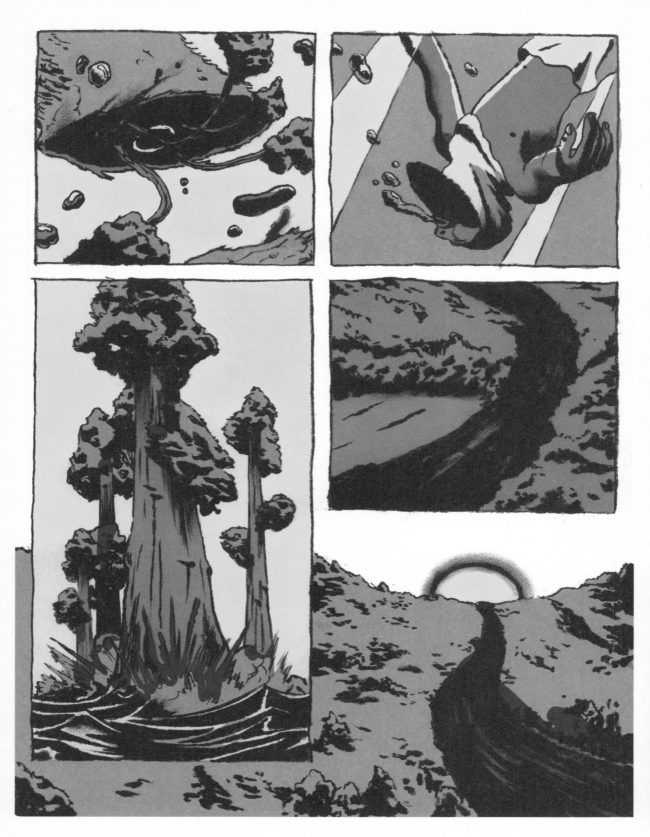

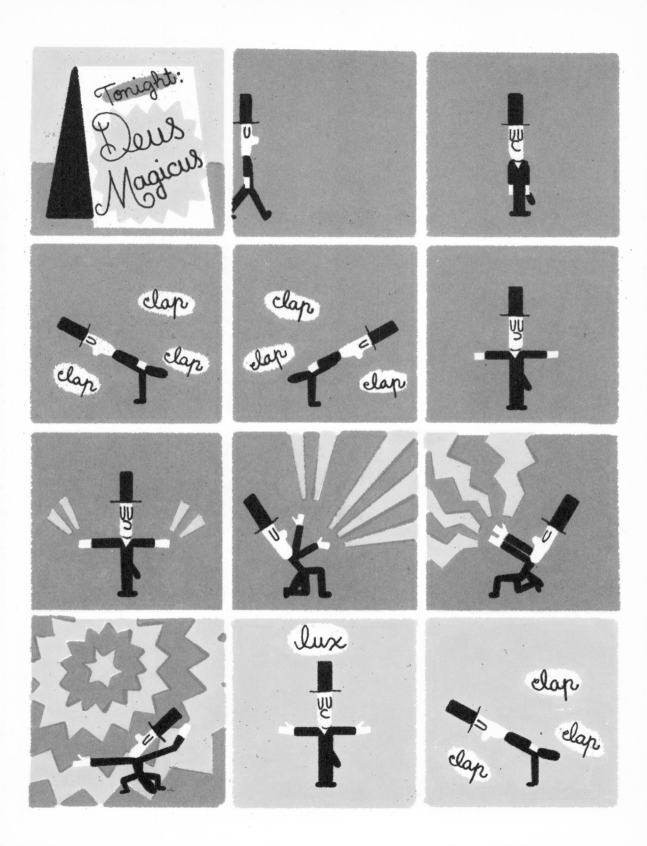

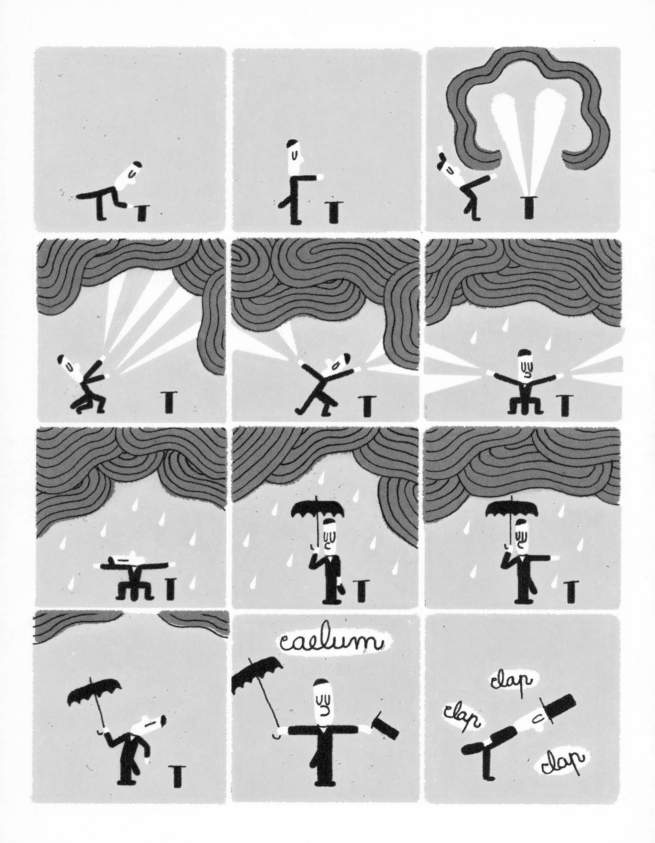

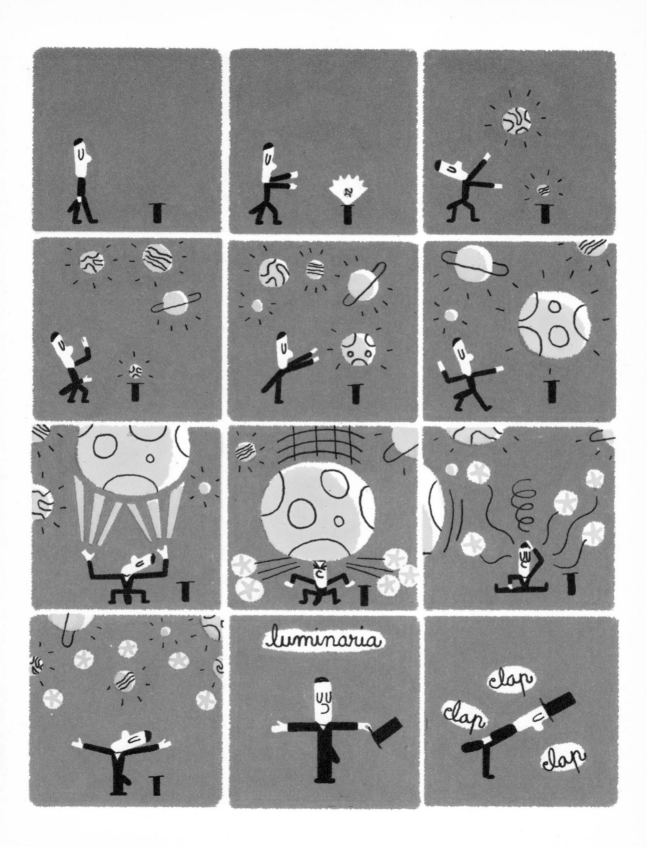

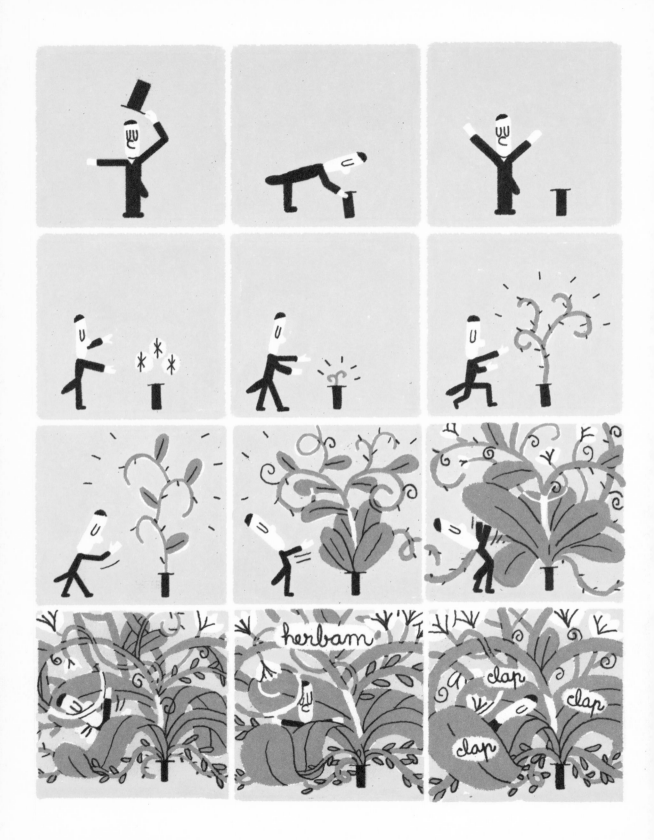

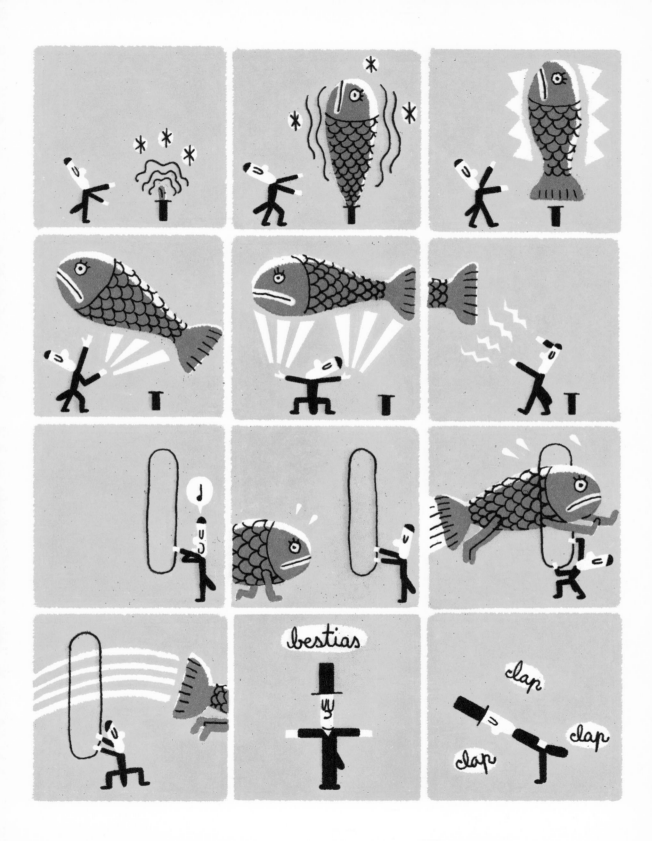

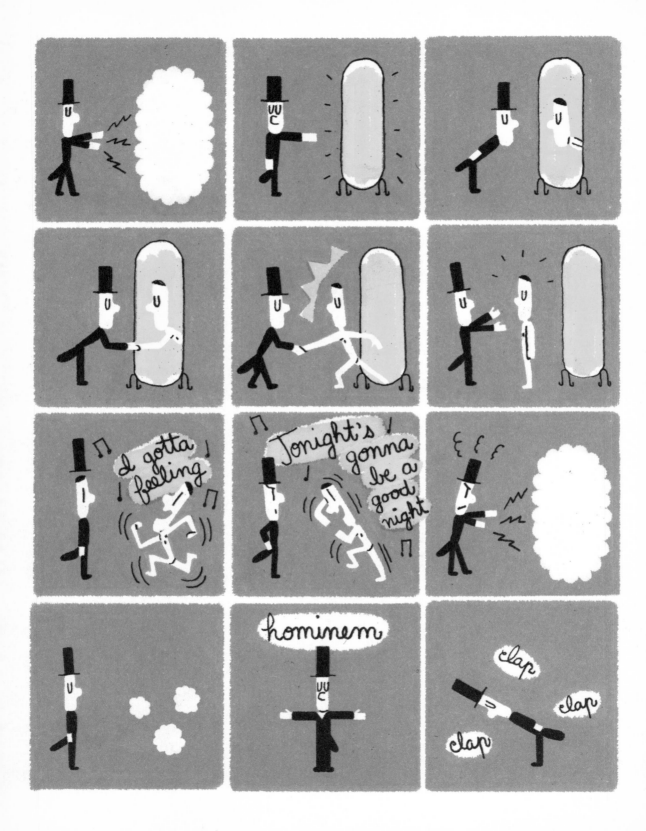

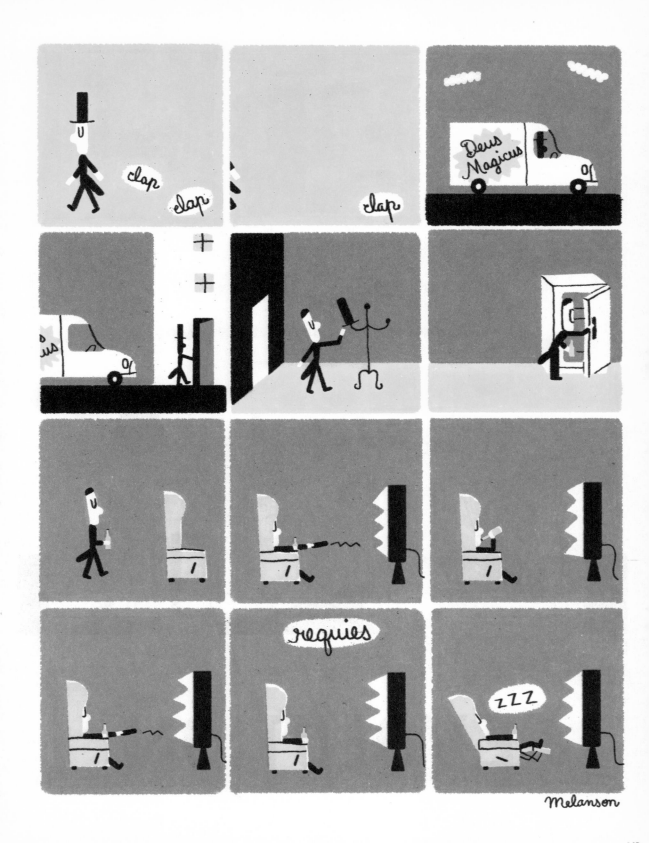

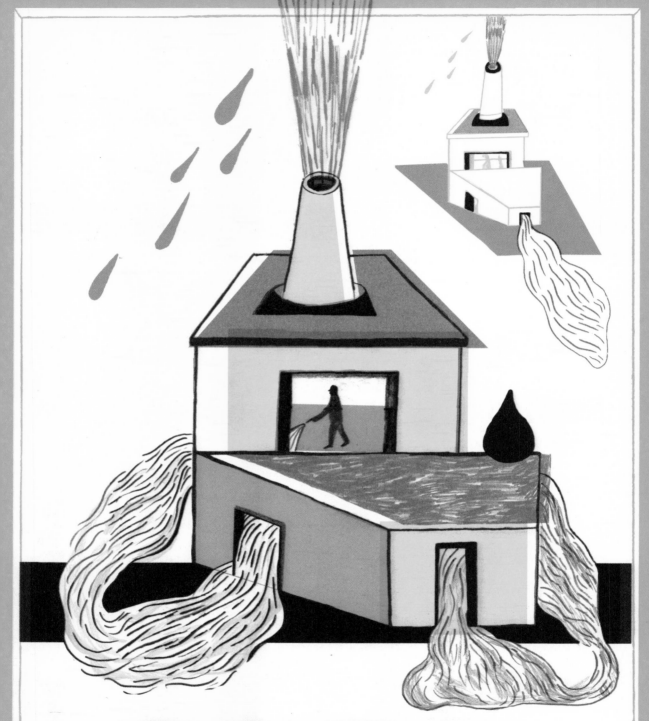

EVOLUTION

BY KATIA FOUQUET

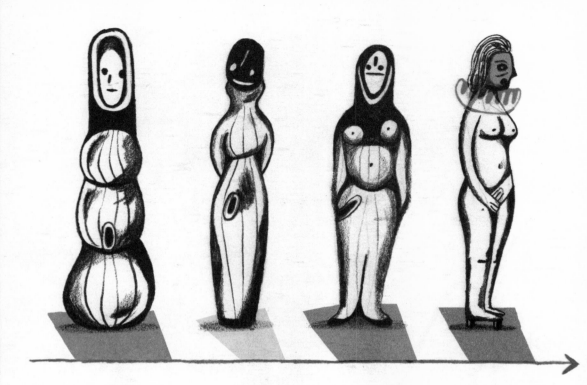

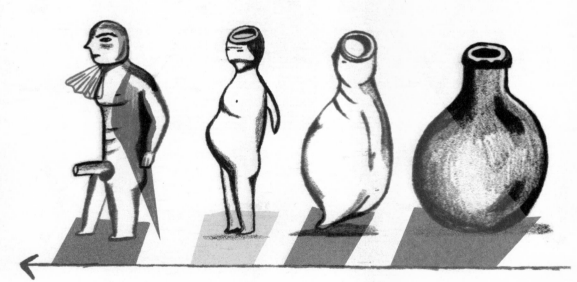

LEADS TO WOMAN
LEADS TO MAN

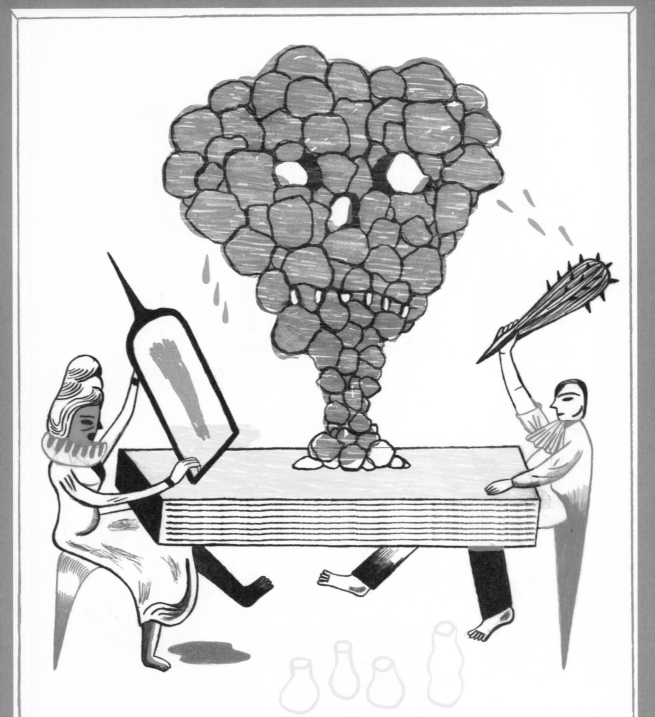

LEADS TO INTIMACY
LEADS TO WAR

LEADS TO WORK
LEADS TO DISTANCE

LEADS TO TELEVISION
LEADS TO LOVE

LEADS TO FAIRYTALES
LEADS TO POWER

LEADS TO HISTORY
LEADS TO ART
ENDS.

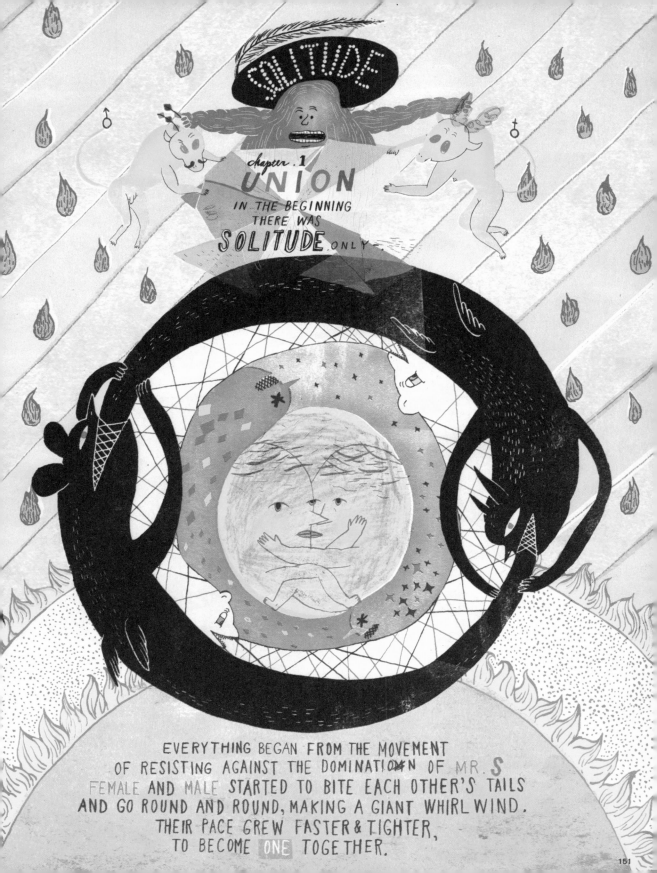

EVERYTHING BEGAN FROM THE MOVEMENT
OF RESISTING AGAINST THE DOMINATION OF MR. S
FEMALE AND MALE STARTED TO BITE EACH OTHER'S TAILS
AND GO ROUND AND ROUND, MAKING A GIANT WHIRLWIND.
THEIR PACE GREW FASTER & TIGHTER,
TO BECOME ONE TOGETHER.

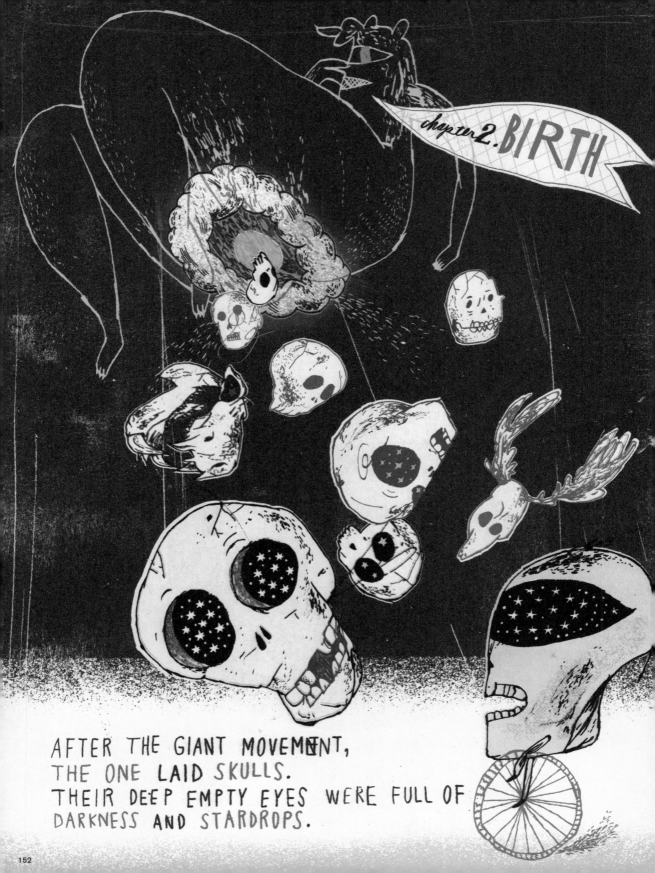

chapter 2. BIRTH

AFTER THE GIANT MOVEMENT,
THE ONE LAID SKULLS.
THEIR DEEP EMPTY EYES WERE FULL OF
DARKNESS AND STARDROPS.

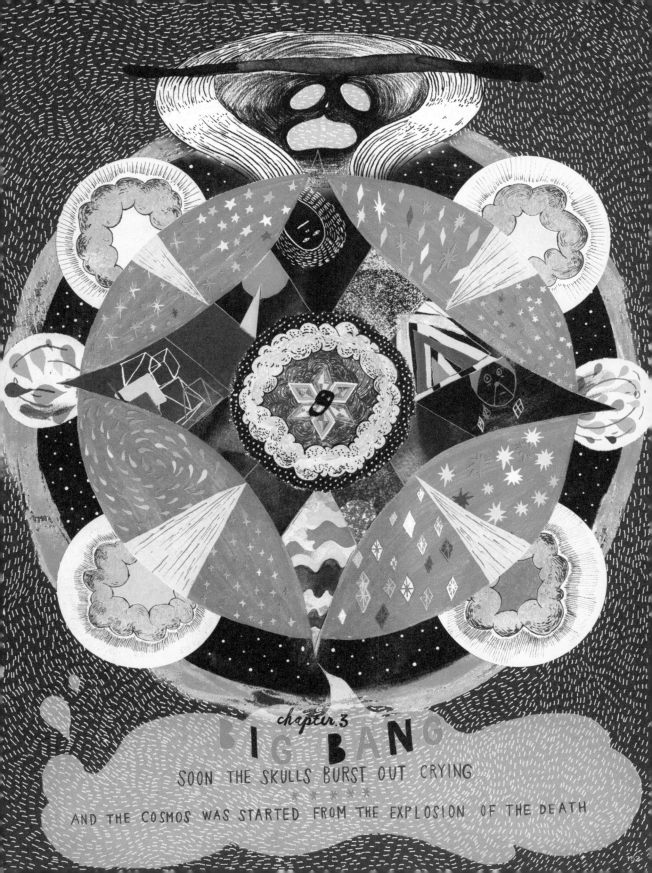

chapter 3
BIG BANG
SOON THE SKULLS BURST OUT CRYING
* * * * *
AND THE COSMOS WAS STARTED FROM THE EXPLOSION OF THE DEATH

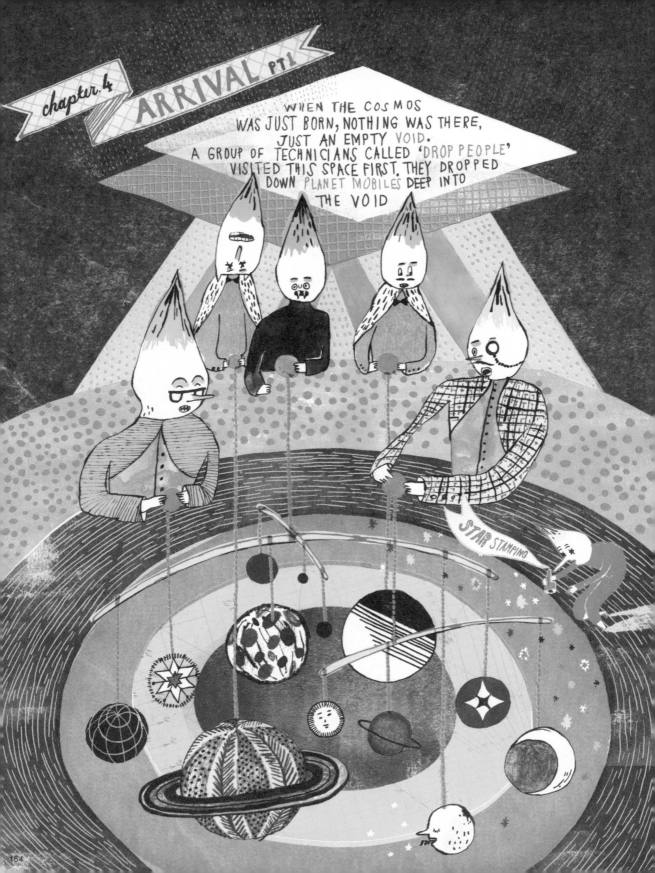

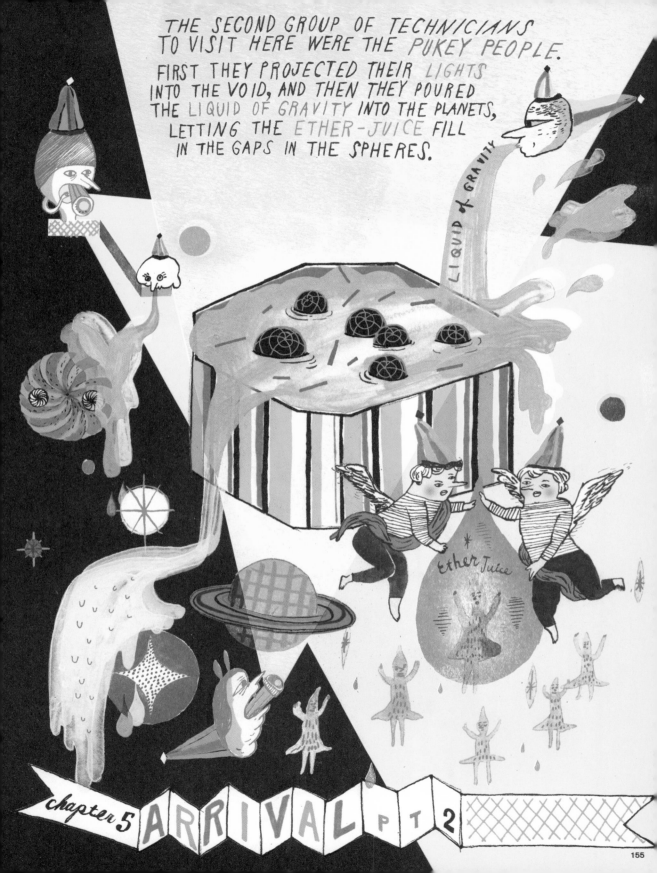

THE SECOND GROUP OF TECHNICIANS
TO VISIT HERE WERE THE PUKEY PEOPLE.
FIRST THEY PROJECTED THEIR LIGHTS
INTO THE VOID, AND THEN THEY POURED
THE LIQUID OF GRAVITY INTO THE PLANETS,
LETTING THE ETHER-JUICE FILL
IN THE GAPS IN THE SPHERES.

LIQUID of GRAVITY

Ether Juice

chapter 5 ARRIVAL PT 2

NEXT, A SPACE BAND ARRIVED.
THEY WANDERED FROM PLANET TO PLANET,
PLAYING SONGS FOR THE NEW WORLDS.
THEIR TUNE AWOKE THE EARTH OF THE PLANETS,
AND SOME FIGURES STARTED TO FORM FROM THE SURFACES,
AND FROM EACH SPHERE DIFFERENT FORMS OF LIFE WERE CREATED.
THEY GREW IN MOTION WITH THE MUSIC AS IF DANCING,
AND WHEN THE BAND HAD FINISHED PLAYING,
THEY HAD BECOME COMPLETE BEINGS,
READY TO BEGIN LIVING.

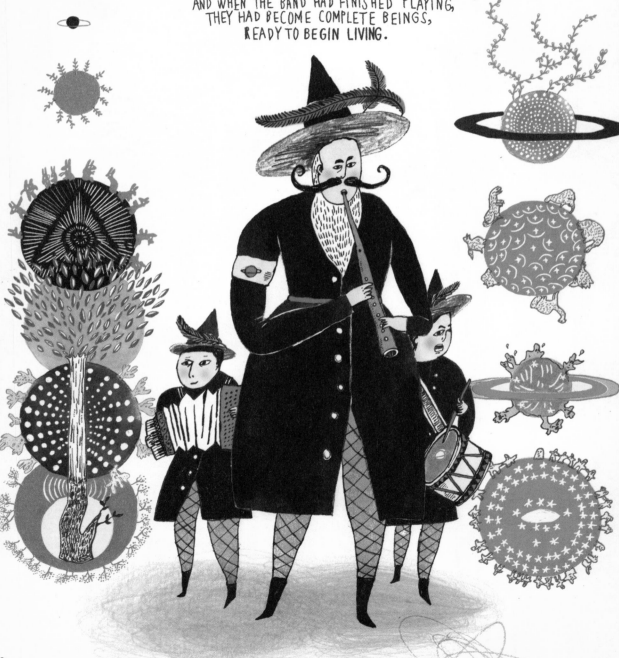

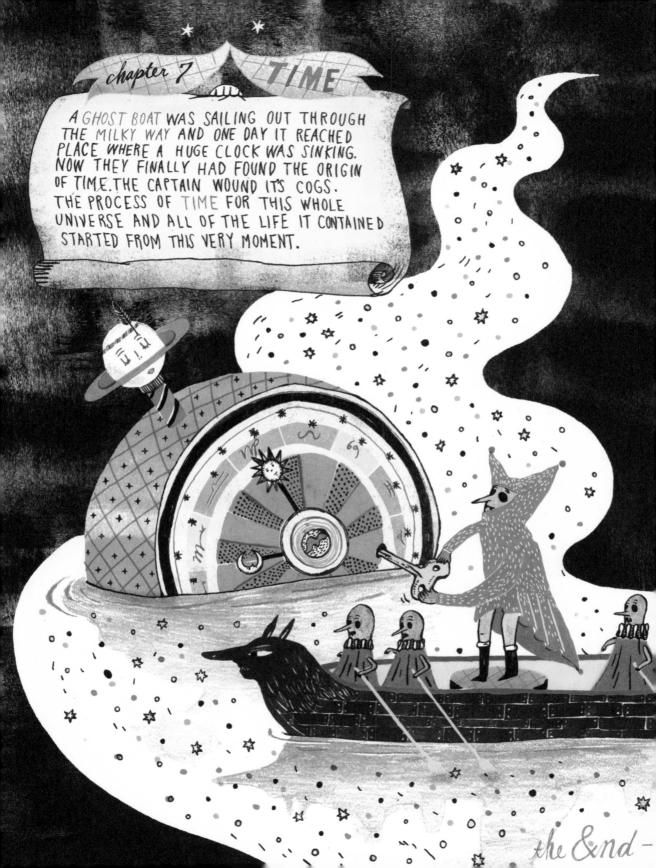

PUSH IT BACKWARDS

BY: MATTHEW LYONS

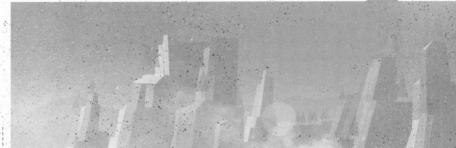

There is a planet called Erutuf. This planet exists on a greater scale and timeline than anyone of us could imagine. Erutuf is just like Earth as we know it. There are beautiful landscapes and creatures roam all over the place.

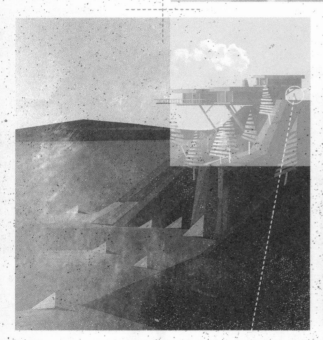

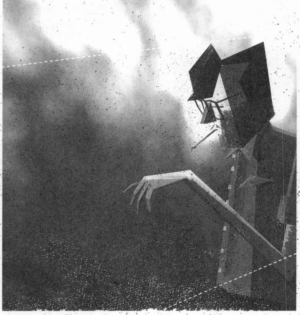

This is Steve who lives on Erutuf. When walking back from work he always thinks about things, for example what he can create and do with his spare time that might impress his best of pals.

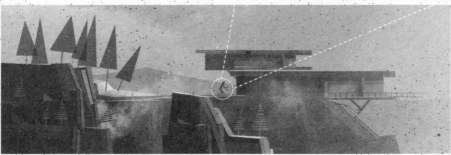

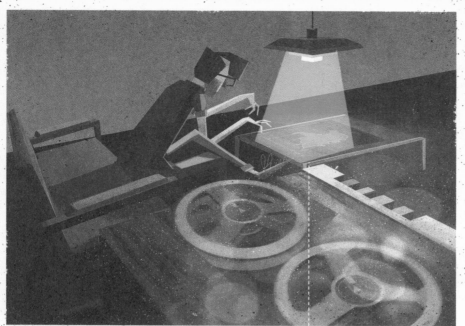

Steve decides to create a new planet, a smaller version of Erutuf. He stays up at night experimenting with different techniques.

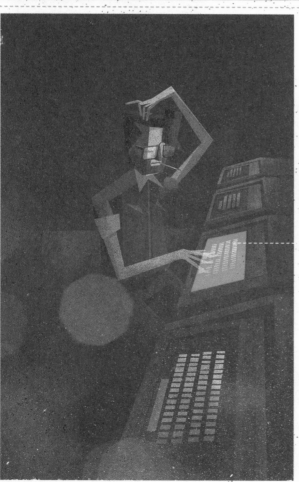

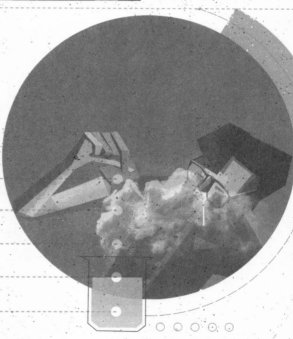

He tries his hand at many different ways of creating a planet, drawing inspiration from several sources to ensure his projects stay fresh like his teeth when he has just cleaned them and can't eat for a while because his mouth tastes of mint.

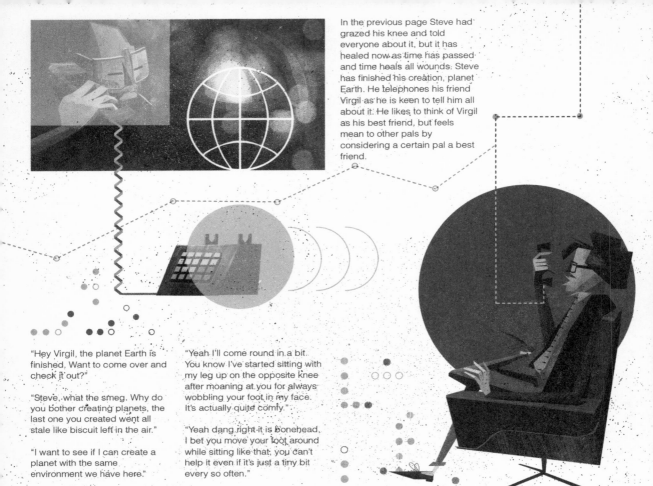

In the previous page Steve had grazed his knee and told everyone about it, but it has healed now as time has passed and time heals all wounds. Steve has finished his creation, planet Earth. He telephones his friend Virgil as he is keen to tell him all about it. He likes to think of Virgil as his best friend, but feels mean to other pals by considering a certain pal a best friend.

"Hey Virgil, the planet Earth is finished. Want to come over and check it out?"

"Steve, what the smeg. Why do you bother creating planets, the last one you created went all stale like biscuit left in the air."

"I want to see if I can create a planet with the same environment we have here."

"Yeah I'll come round in a bit. You know I've started sitting with my leg up on the opposite knee after moaning at you for always wobbling your foot in my face. It's actually quite comfy."

"Yeah dang right it is bonehead, I bet you move your foot around while sitting like that, you can't help it even if it's just a tiny bit every so often."

Virgil put down the phone after the conversation slowly died. He starts the journey to Steve's house and juggles thoughts about the economy, evolution and why flies buzz in to his room. They have all the space to roam in, but they choose the one tiny gap when his window's slightly ajar.

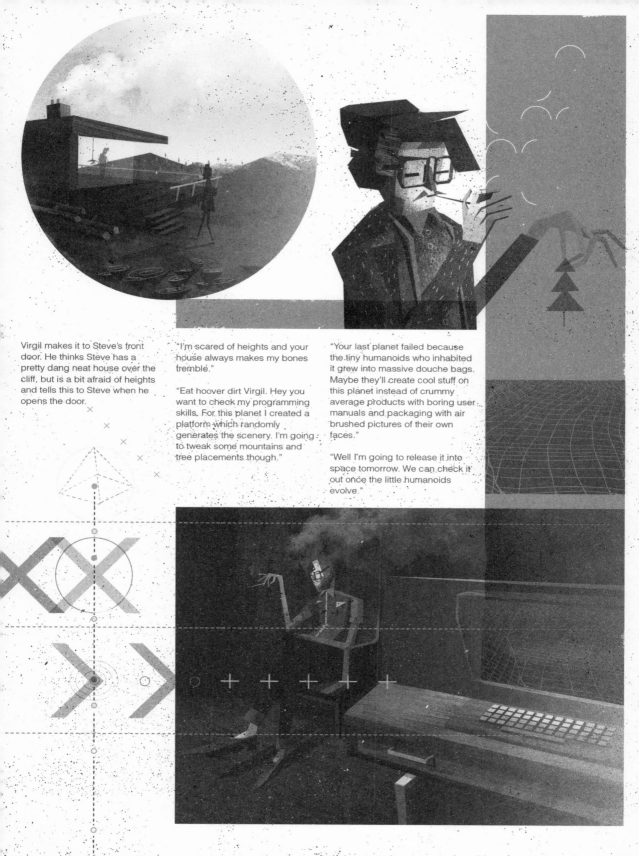

Virgil makes it to Steve's front door. He thinks Steve has a pretty dang neat house over the cliff, but is a bit afraid of heights and tells this to Steve when he opens the door.

"I'm scared of heights and your house always makes my bones tremble."

"Eat hoover dirt Virgil. Hey you want to check my programming skills. For this planet I created a platform which randomly generates the scenery. I'm going to tweak some mountains and tree placements though."

"Your last planet failed because the tiny humanoids who inhabited it grew into massive douche bags. Maybe they'll create cool stuff on this planet instead of crummy average products with boring user manuals and packaging with air brushed pictures of their own faces."

"Well I'm going to release it into space tomorrow. We can check it out once the little humanoids evolve."

HUMANOIDS HAVE EVOLVED ON EARTH

Steve is excited. He hasn't checked out his creation since he placed the tiny planet he called Earth in space. Steve talks to himself in a mumbly way while cruising the surface of Earth.

4:57

5:28

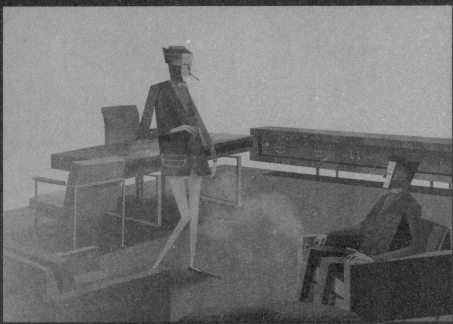

○ "First I'll check out the coastlines I drew out. oooooo yes check out that bad ass architecture. Wow this must be the first time they go into space as well. All that fuel just to get a few millimetres, still they seem to be evolving nicely. I'll just spy on them in this office."

○ "HELLO JONATHON."

○ "HELLO ADRIAN."

○ "JONATHON CAN I ANIMATE A SCENE WHERE THE DOG GETS PUMMELED INTO THE SHAPE OF A FLOPPY SAUSAGE."

○ "YES ADRIAN YOU ARE THE EXPERT I SHALL JUST PUBLISH THE THING."

○ "THANK YOU JONATHON."

○ "BYE ADRIAN."

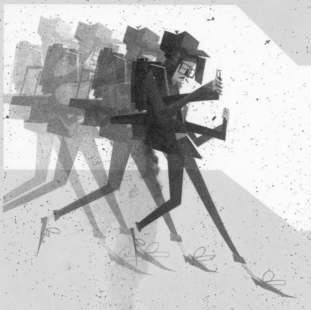

A few years have passed on
Erutuf and Virgil hasn't seen
Steve in ages. However he is
back from travelling around for
business and drops by on Steve
by jetpack. When Virgil meets
Steve he pretends Steve's face
hurts his eyes.

"Steve I need to shield my eyes
because your face is hurting
me."

"Hey Virgil come in."

"I just thought, how is that Earth
thing coming on, when we last
spoke you told me they were
creating some pretty neat stuff."

"Woah yeah I haven't checked it
since last time been so busy.
Let's check it out on the big
screen."

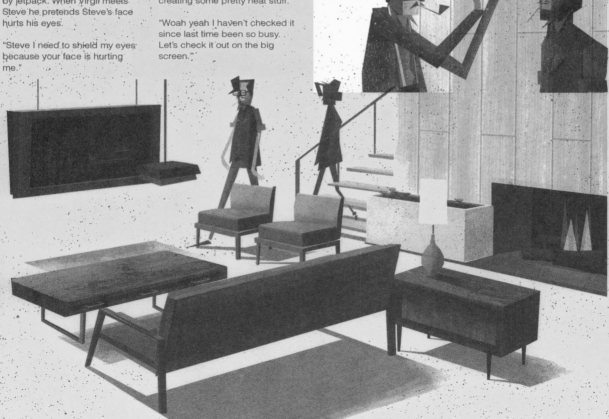

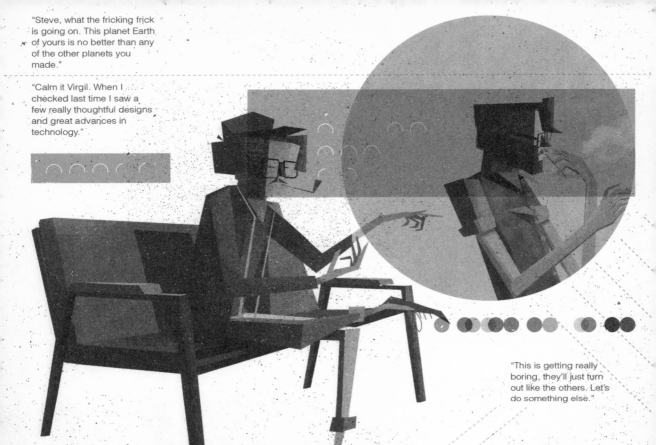

"Steve, what the fricking frick is going on. This planet Earth of yours is no better than any of the other planets you made."

"Calm it Virgil. When I checked last time I saw a few really thoughtful designs and great advances in technology."

"This is getting really boring, they'll just turn out like the others. Let's do something else."

"OK DARREN HERE IS YOUR TERMINAL. EVERYTHING IS ALREADY DRAWN FOR YOU. ALL YOU HAVE TO DO IS CLICK BUTTONS."

"DENNIS CAN I MAKE A POSTER FOR THE STAFF ROOM TELLING PEOPLE TO WASH UP THEIR MUGS."

"DARREN THAT IS A GREAT IDEA, BUT MAKE SURE TO KEEP IT NICE AND COLOURFUL SO IT'S EYECATCHING. SHOW ME WHEN YOUR DONE SO I CAN CHEC IT'S OK."

"THANKS DENNIS."

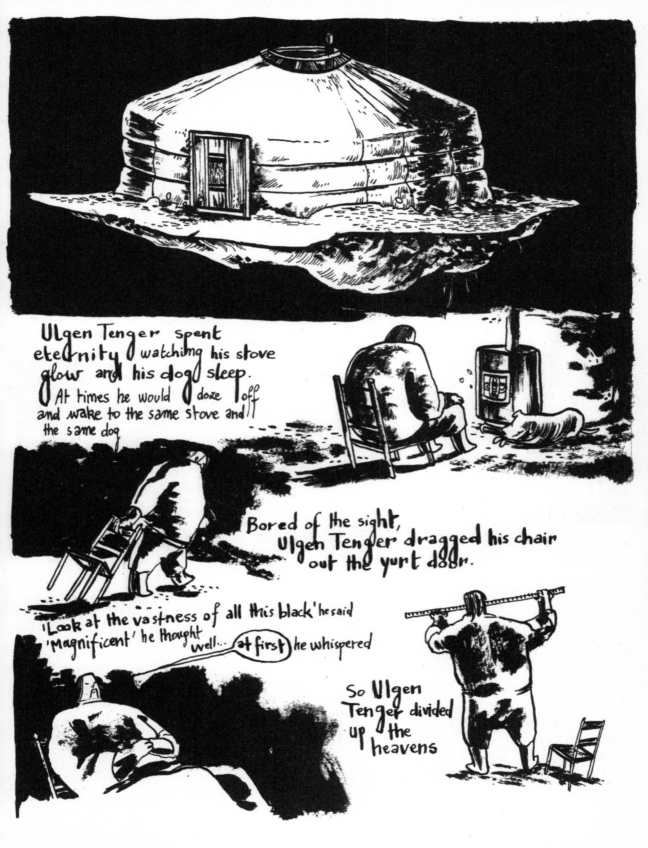

Ulgen Tenger spent eternity watching his stove glow and his dog sleep.

At times he would doze off and wake to the same stove and the same dog

Bored of the sight, Ulgen Tenger dragged his chair out the yurt door.

'Look at the vastness of all this black' he said
'Magnificent' he thought
well... (at first) he whispered

So Ulgen Tenger divided up the heavens

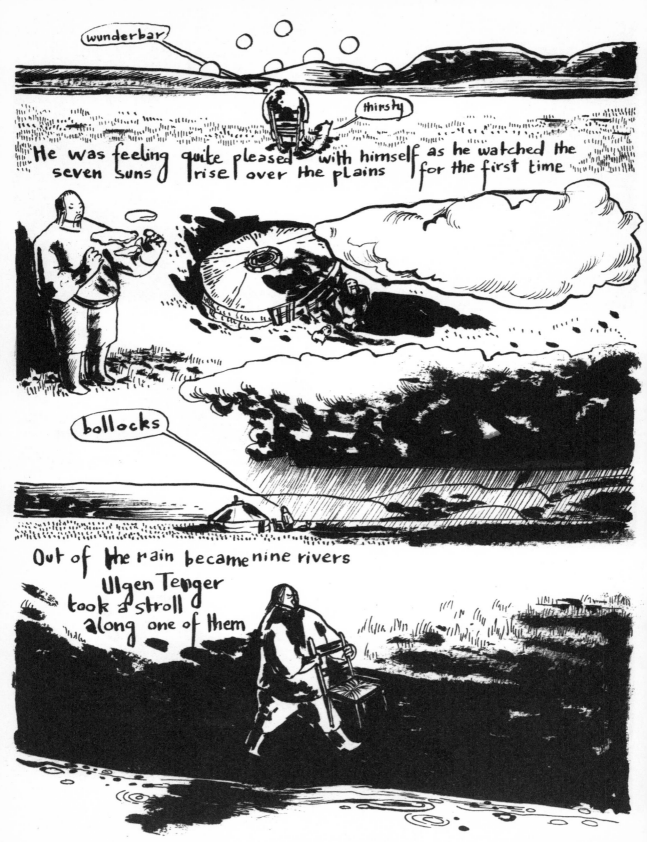

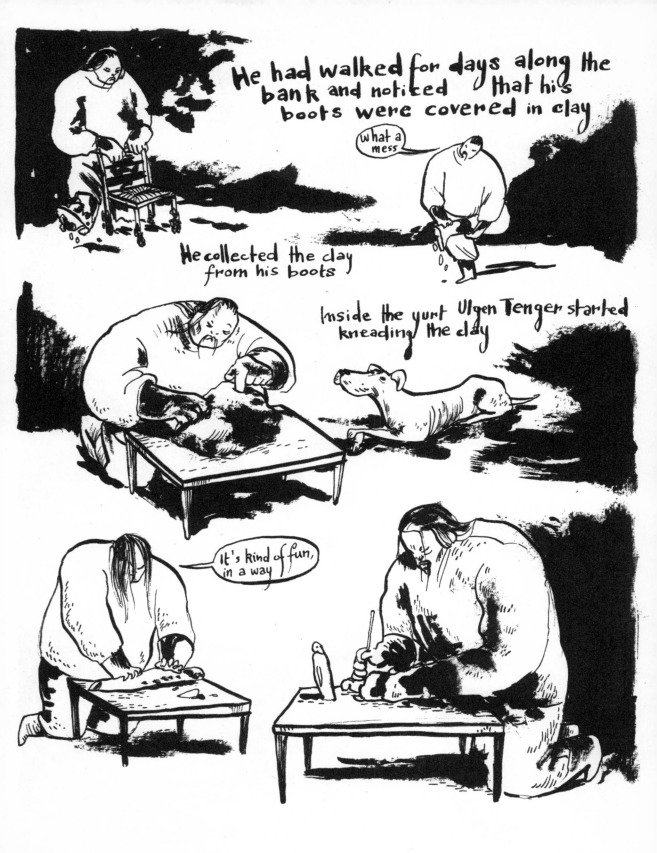

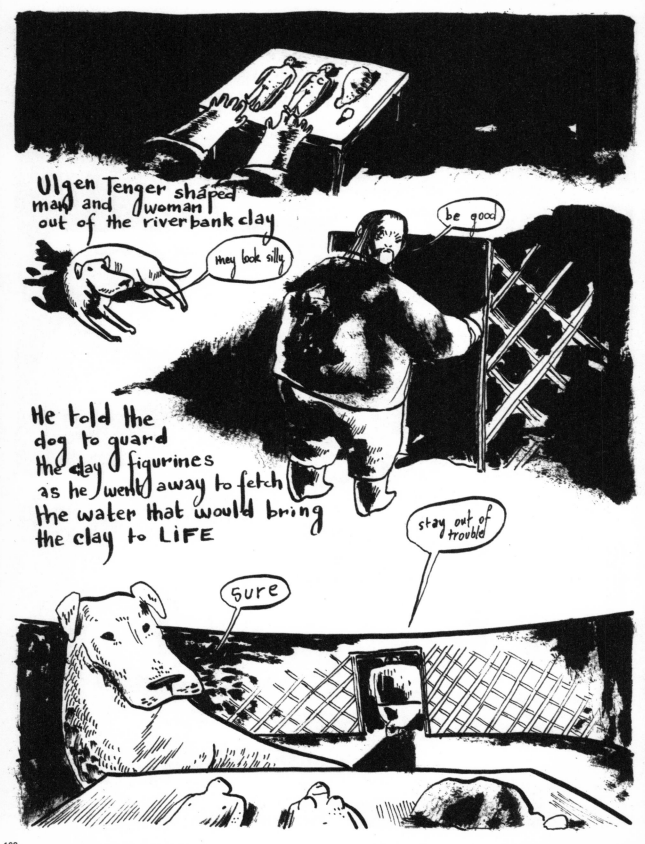

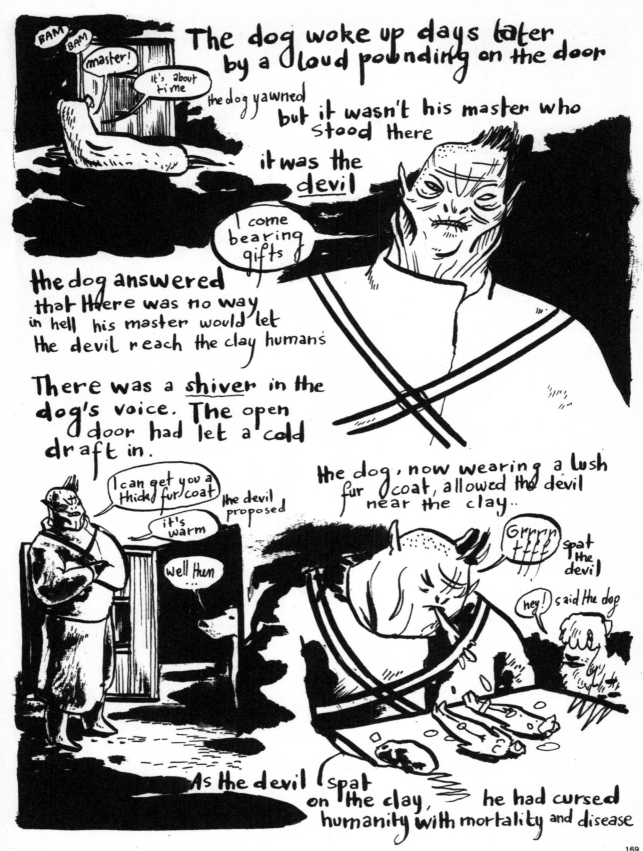

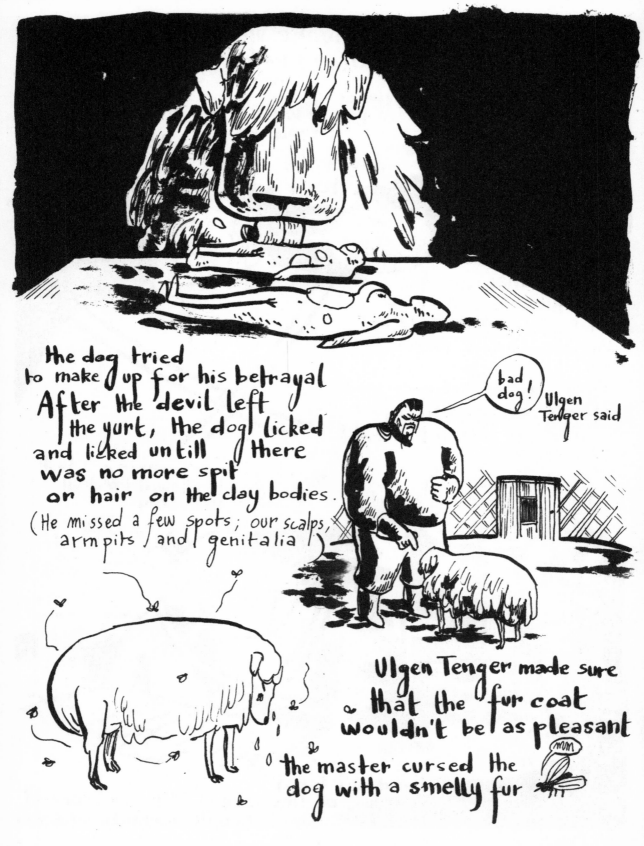

the dog tried
to make up for his betrayal
After the devil left
 the yurt, the dog licked
and licked untill there
was no more spit
or hair on the clay bodies.
(He missed a few spots; our scalps,
 armpits and genitalia)

bad dog! Ulgen Tenger said

Ulgen Tenger made sure
that the fur coat
wouldn't be as pleasant

the master cursed the
dog with a smelly fur

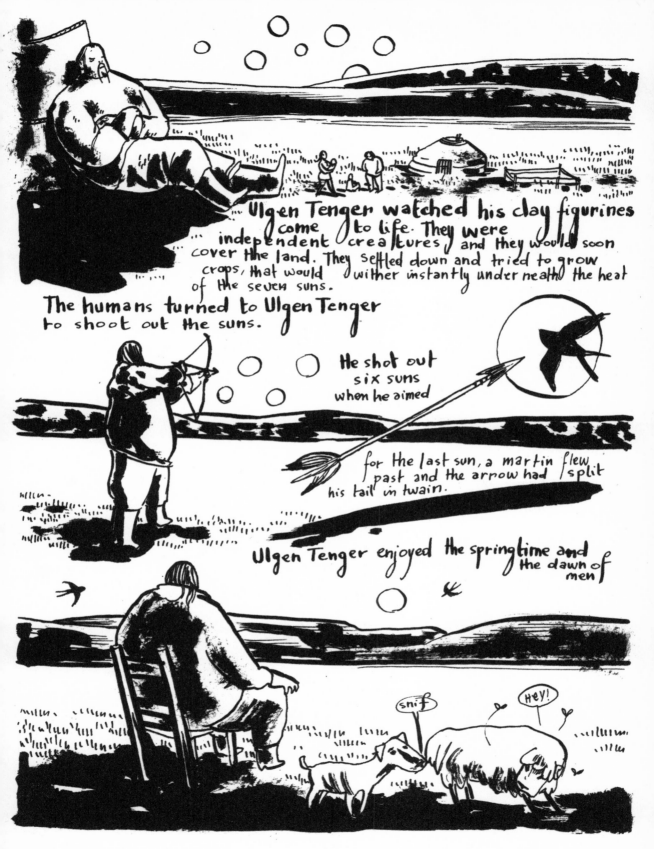

Ulgen Tenger watched his clay figurines come to life. They were independent creatures and they would soon cover the land. They settled down and tried to grow crops, that would wither instantly underneath the heat of the seven suns.

The humans turned to Ulgen Tenger to shoot out the suns.

He shot out six suns when he aimed

for the last sun, a martin flew past and the arrow had split his tail in twain.

Ulgen Tenger enjoyed the springtime and the dawn of men

snif

Hey!

WWW.NOBROW.NET

A Graphic Cosmogony is © 2010 Nobrow Ltd.

Editor: **Alex Spiro**
Assistant Editor: **Ben Newman**
Production Manager: **Sam Arthur**
Concept and Design: **Alex Spiro**
Additional Design and Typography: **Natasha Demetriou**
Cover and Endpapers: **Micah Lidberg** - www.micahlidberg.com
Introduction: **Paul Gravett** - www.paulgravett.com

Thanks to: Ben for his ideas, talent sourcing and suggestions; Paul Gravett for his support of the
project and for writing such an apt and erudite introduction; Natasha Demetriou for her diligence and
patience; and finally all of the artists for tackling that most confounding of conundrums with imagination,
humour and a light heart: Mike Bertino, Luke Best, Jon Boam, Liesbeth De Stercke, Katia Fouquet,
Isabelle Greenberg, Jakob Hinrichs, Sean Hudson, Rob Hunter, Clayton Junior, Stuart Kolakovic,
Daniel Locke, Matthew Lyons, Jon McNaught, Luc Melanson, Ben Newman, Luke Pearson, Andrew
Rae, Mikkel Sommers, Jack Teagle, Rui Tenreiro, Brecht Vandenbroucke, Nick White and Yeji Yun.

Published by
Nobrow Ltd.
62 Great Eastern St.
EC2A 3QR
London

Printed in Italy

If you are interested in stocking Nobrow products or publications or have any queries regarding our
wholesale terms, please refer to our website.

www.nobrow.net

ISBN: 978-1-907704-02-4

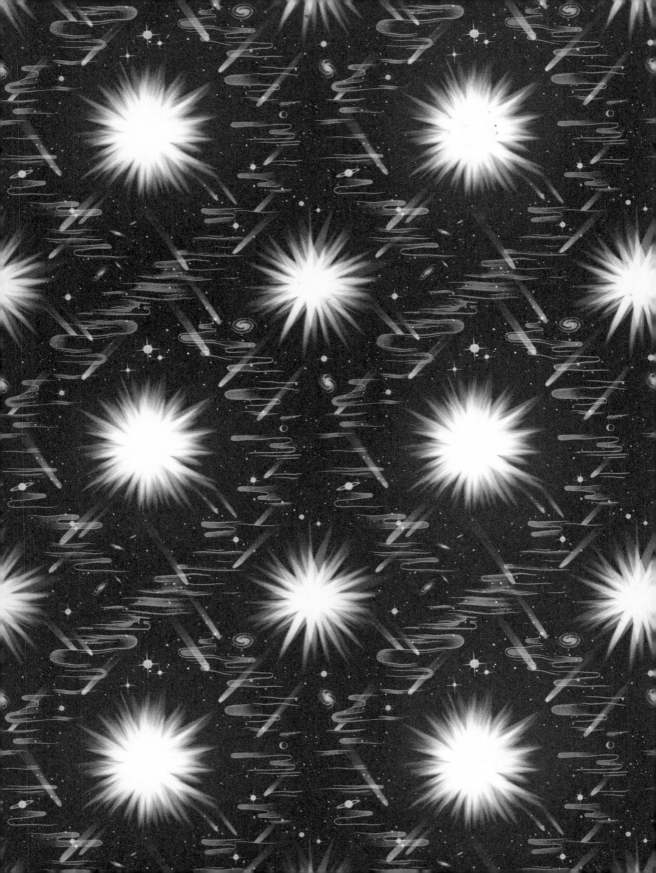